Thomas Elfe: Cabinetmaker

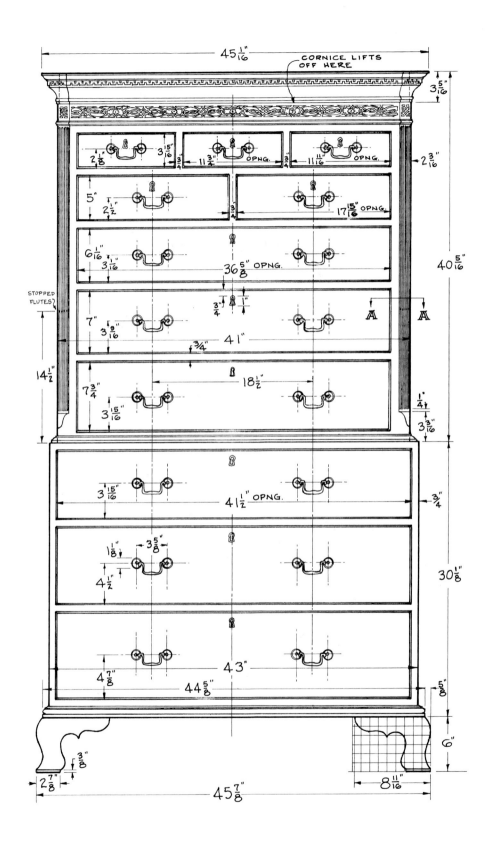

Thomas Elfe: Cabinetmaker

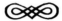

Samuel A. Humphrey

WYRICK & COMPANY

Published by Wyrick & Company
Post Office Box 89
Charleston, SC 29402

Designed by Paul Rossmann
Printed in Hong Kong

Library of Congress Cataloging-In-Publication Data

Humphrey, Samuel A.
 Thomas Elfe, cabinetmaker / Samuel A. Humphrey
 p. cm.
 Includes bibliographical references and index.
 ISBN 0-941711-15-3
 1. Elfe, Thomas, 1719-1775. 2. Cabinetmakers—South Carolina—
Charleston—Biography—History and criticism. 3. Furniture—South
Carolina—Charleston—History—18th century. I. Title
 NK2439.E4H86 1994
 749.213—dc20
 [B] 94-14034
 CIP

Contents

Preface and Acknowledgements

This book happened because Elizabeth Currie's eighth grade teacher asked her to write a paper on Thomas Elfe. Recalling my interest in furniture, her mother suggested an interview. When Elizabeth arrived, I was ready with details and a sample I'd made of the famous Elfe fret. She got an "A" on her paper and Elfe hooked me, ultimately leading to the book.

The friendly and generous people of Charleston make a book like this possible. Once I decided to proceed with the drawings and research required to tell this story, it wasn't long before a neighbor, Gene Clark, recalled that his Citadel classmate had owned a Thomas Elfe chest. A meeting was arranged, and I'll never forget the excitement I felt on first seeing that majestic chest. The owner, Henry Ravenel Dwight, Jr., is a gracious, scholarly Charleston gentleman. He became enthused over this book project and whole-heartedly threw himself into arranging meetings with other Charleston furniture owners. We became good friends, and without his help this book would not have been possible.

Several of the other people who offered help and encouragement were Wallace Frampton, Peter and Maree Schwerin, Charleston antique dealers; Cam Alexander of the S.C. Historical Society; Harlan Greene and David Moltke-Hanson formerly of that organization; John Bivins, Jr., former staff member, and Brad Rauschenburg of Museum of Early Southern Decorative Arts; Benny Sharpe, Edward D. Sloan, Jr. and William P. Baldwin all helped locate out-of-town pieces.

Ruth Miller, a Writing Instructor at the College of Charleston, pointed me in the right direction and introduced me to Pete Wyrick, the publisher who made it happen. Minnie Haig, former Head Librarian of the Charleston Library Society, helped find material and showed me the original Elfe Account Book.

Mrs. Virginia Elfe Zeigler, her son John Zeigler and daughter Mrs. Virginia Potter (all descendants of Elfe) provided family information.

Robert Saarco, a present-day cabinetmaker, arranged for permission to measure and photograph the Miles Brewton armchair. Several other private owners of furniture examined in this book allowed measurements and photographs, including James Gibbs, Hill Carter, the Sinkler family, and Alson Goode. Danny Hinson, another contemporary Charleston cabinetmaker, loaned his pediment pattern for the "Mystery Chest." Although I have tried to prepare and check the drawings in

this book as carefully as possible, no responsibility for their accuracy is assumed.

Frank Horton, before he retired as Director of MESDA (Museum of Early Southern Decorative Arts), graciously provided a large quantity of MESDA research information and permitted measurements and photos of several pieces in their collection. Mary Vereen Hugenin arranged access to Pompion Hill Chapel.

Former Governor James Edwards and Governor Carroll Campbell of South Carolina made arrangements for me to examine the field bed in the Governor's Mansion. The staff of the Mansion provided valuable assistance.

Tom Savage, Curator of the Nathaniel Russell House, provided access to their "Dressing Drawers."

The Charleston Museum's collection in the Heyward-Washington House, as well as the files at the museum, were made available by Chris Loeblein, Historic Curator. Access to the alphabetical index of names in the Elfe Account Book was provided by Catherine Gaillard of the Museum staff. Although he died before I could have known him, E. Milby Burton, through his writings and dedicated scholarship as Director of The Charleston Museum, provided much of the knowledge we have of Thomas Elfe and the inspiration for this book.

At Middleton Place, Sarah Lytle and Susan Bison provided access to the collection and clarified some historic details.

At the S.C. State Museum in Columbia, S.C., Fritz Hamer and Winona Darr provided access to the Governor's Chair (with permission from the McKissick Museum, from which it is on loan).

Terry Richardson, Visiting Associate Professor of Physics at the College of Charleston, took many of the excellent color photographs for this work.

Caroline Hunt, English Professor at the College of Charleston, did the first edit on the manuscript to make it readable, and Roberta Kefalos and Pete Wyrick completed the treatment. Pete also guided me to several museum directors with suggested approaches, encouraged me and, best of all, published my book.

Finally, my wife Peggy deserves a great deal of credit for her patience and support. She has been wonderful.

Samuel A. Humphrey

Introduction

Some time before 1747, Thomas Elfe (1719-1775) arrived in Charles Towne, in South Carolina, wealthiest of the English colonies. He came with tools, a trade, money and he came at the best of all times to be in South Carolina. It was between wars, the pirates were gone, and the planters, merchants and politicians were prospering as rice exports mushroomed. Individual wealth in Charleston was to grow by 1774 to six times greater than that of New York or Philadelphia. Charleston was rich. It was also the cultural and social center of the colony. Lavish mansions sprang up all over town. Providing furnishings in the latest London fashion for these homes gave steady work to the Charleston cabinetmakers.

E. Milby Burton (1889-1977), former director of the Charleston Museum, wrote several books and articles calling national attention to the excellence and beauty of Charleston furniture, some of which he attributed to Thomas Elfe.

Burton's research of old records identified many of the Charleston cabinetmakers, pinpointing Elfe as the most admired and respected, and the only one from whose business an account book survives. That original account book is still in the archives of the Charleston Library Society. During the period covered (1768-1775), the account book reveals that Elfe's shop sold over 1600 items of furniture.

Burton found a set of related characteristics amongst the Charleston pieces, as well as several supporting circumstances encompassing a large body of furniture, and he attributed it all to Elfe, although it is more likely that several hands working under Elfe's direction were responsible. More characteristics and supporting circumstances are identified herein; however, identification remains largely conjectural.

Thomas Elfe's Account Book has ensured his place in history. As the only surviving example from an eighteenth century Charleston cabinetmaker, it presents a valuable record of the last eight years in his life and work. It appears to be the top book of a more complete set covering sub-accounts. There must have been others for earlier periods, but none of the others have yet been found. The account books of Thomas Chippendale's firm did not even survive, so this book's importance to our understanding of Elfe and other artisans of the period may be seen.

Elfe's Account Book suggests that his sales averaged about 17 pieces each month;

Cash &c.a for the Gold Silver & Paper Currency by me £1020.–

House the Corner of Friend & Br.d St. }5000.–
 which I Value at ––––––––

House in Broad Street N.o 2
 which I Value at ––––––––––––– 5500.–

Houses in Broad Street N.o 3 & 4
 which I Value at ––––––––––– 3000.–

Lot & Shop in King Street
 which I Value at –––––––––– 1300.–

Plantation on Daniels Island
 with Cattle & Horses which I Value at 1500.–
 Working Negroes & their Children &c.a 1000.–

Negroes to the Value of ––––––––– 6650.–

Mahogney to the Value of ––––––– 300.–

Cypress ... to the Value of –––––– 50.–

Bonds & Notes

 for Henry Gray & Zachariah Villepontoux } 500.–
 the amo.t of their bond
 Henry Gray & Stephen Millar Amo.t of that D.o 500.–
 Jos. Ball Philip Myre & Wm. Hall Amo.t of D.o 2000.–
 Ja.s Drumond & Wm. Burrows Amo.t of their D.o 830.–
 Samuel Hopkins –––––– Amo.t of this Bond 650.–
 Daniel & John Heyward Amo.t of their D.o 990.–
 John Marley & Derby Pendergrass –––– D.o 700.–
 Mary Frost –––––– D.o 300.–
 Stephen Townsand –––––– D.o 303.–
 Townsand & Sons

FIGURE 1

however, very few furniture sales were actually recorded in the first three years, possibly because there had been a separate account book for his years of partnership with John Fisher. The average monthly rate during the five years showing sales in this Account Book was closer to 30 pieces per month (Figure 1). In July, 1772, his best month, he actually sold 81 separate pieces. His last eight year total may have been closer to 2500 pieces and his 28 year total may have been as many as 5000 pieces. Elfe did not actually make all of the furniture himself; instead, these were the quantities his shop sold.

The surviving Account Book is impressive. Almost two inches thick, it is bound in light tan leather and measures approximately eleven by seventeen inches. The entries are clearly written in bold, cursive strokes with flared curves typical of a quill pen. No ruled lines are visible, yet the writing is perfectly straight on the pages, with even borders and a consistent format. All of the pages are of fine paper, although yellowed with age and with writing on only one side. The ink is brown and slightly faded.

The first entries listed his assets, worth £ 44,000 South Carolina money. (One English £ was worth seven S.C. £s.) Although Elfe's Account Book figure was higher than the £ 38,243 inventory of his estate made in 1776, the inventory was in the top four percent of those filed in the colony during the previous decade. In today's dollar amounts, Thomas Elfe was easily a millionaire.

Thomas Elfe

The lives of Thomas Elfe (1719-1775) and the great English cabinetmaker and designer Thomas Chippendale (1718-1779) had many parallels (Figure 2). Born in England within a year of each other, they grew up in London where they served their apprenticeships; Chippendale under his father who opened a shop there in 1727, and Elfe under his uncle.

Elfe inherited his uncle's money and tools, and moved to Charleston by way of Virginia. With finances, tools and valuable training in the latest furniture fashions, he quickly established himself as a cabinetmaker. Typical of Elfe's good fortune, he became such a good friend of Thomas Watson, a Charleston joiner and carver, that Watson left him his estate when he died in 1747.

First notice of Elfe in Charleston newspapers occurred the 6th of October, 1747, when his shop provided a pair of large, carved, gilt sconces, valued at about 150 pounds (several thousand dollars in today's money), for a raffle.

Both Elfe and Chippendale married in 1748. Elfe's wife was Mary Hancock, a widow. Both men were widowed — Elfe in his first year of marriage and Chippendale in his 24th. Both remarried. Elfe's second wife was Rachel Prideau, whom he married in 1755. He had six children by her: William, Elizabeth, Hannah, George, Thomas and Benjamin.

Both men left their businesses to their sons; the eldest son of Chippendale (also a Thomas) operated his father's business at the same address in St. Martin's Lane for another 40 years, while one of Elfe's sons (the only cabinetmaker and another Thomas) carried on his business. Elfe's boy was a teenager when his father died. The will specified:

...if it is the will and desire of Thomas, that the business be kept for him until he is of age.

He also left Thomas "land in King Street" and the shop there which he had paid William Patterson £ 32.10 to build in 1770, as well as "tools, benches, mahogany of all kinds, locks, brasses, and every other article pertaining to the business".

In his will he valued this lot and shop at 1300 pounds and his house at the corner of Friend (now Legare) and Broad Street at 5000 pounds. That house was left to Elfe's son, George, after his death and is believed to have stood on the southeast corner. It must have been lost at the time of the 1861 fire in Charleston; if not

before, since the fire took the buildings on all four corners. All buildings there today are of a later date.

That same fire is believed to have also taken the house on the rear of the lot at 54 Queen Street behind the present "Thomas Elfe Workshop", a small, mid-eighteenth century house which sat on the front of the lot. It was moved back from the street to provide parking spaces and was restored in 1968.

Chippendale was unquestionably a master designer, recorder, combiner and refiner of then-fashionable designs. He published three editions of his *Gentlemen's*

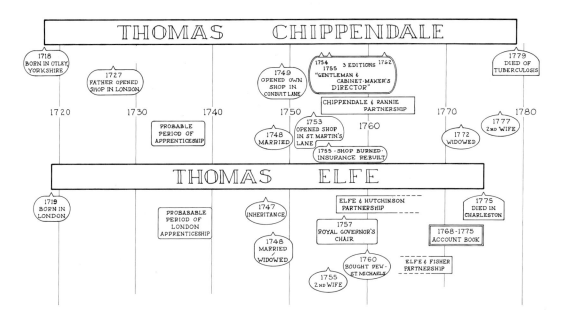

Figure 2

and *Cabinetmaker's Director* (1754, 1755 and 1762). Elfe's double-chests, based on those designs, exhibit proportions and elegance superior to most American chests of the period — including the Philadelphia ones.

Elfe and Chippendale died within 4 years of one another, and both lived through the turbulent years leading to the American Revolution without either seeming to have been personally affected; however, Elfe, like many of the Charleston merchants, was a Tory and his wife and children suffered for it.

The designs in Chippendale's *Director* actually represent several different styles of furniture fashion: Georgian, Gothic, Rococo, Chinese, and French. He worked with the Adam brothers in his later years and appears to have been preparing a fourth edition including drawings of their works.

The first drawings in the *Director* were obviously prepared before 1754 and reflected then-current designs. Elfe may have seen some of those designs before he left London in the 1740s, or he may not have seen them till the *Director* appeared.

Copies of Chippendale's book were owned by Louis XVI of France and Catherine the Great of Russia. Copies quickly circulated to English and Colonial cabinetmakers. While no record exists that Elfe had a copy, he most likely did. Even a Charleston bookstore is known to have had copies for sale. Unfortunately, Elfe's copy may have been discarded during the chaos surrounding his death and the start of the Revolution, or when the business was closed. It may have been given or sold to Walter Russell, an upholsterer who lived at Elfe's Broad Street home, since one appeared in Russell's estate inventory just a year after Elfe died.

Several examples of Elfe pieces made to Chippendale's designs are illustrated in this book. Many of those designs were records of other designer's work, and all were pictorial sketches rather than detailed working drawings so that each individual cabinetmaker interpreted the designs and made his own working drawings and patterns.

Elfe saw the worth of drawing instruction. In January, 1771, he paid Mr. Eusebuer 19.5 pounds for teaching his own son to draw. Chippendale, according to Christopher Gilbert, probably learned drawing in Hubert Gravelot's drawing school.

Elfe did not have the artistic inventiveness of Chippendale. Instead, Elfe perfected a set of detailed designs of furniture such as beds or chests, some based on Chippendale's designs, and then did not vary greatly. This allowed him to develop standardized prices and, importantly, to produce work assignments for his various workmen.

Chippendale did not show construction details in his books. That was left to the individual cabinetmaker such as Elfe whose joinery was practical, solid and strong. It resulted in a high survival rate for his furniture, in spite of wars, pillage, hurricanes, fires and style changes.

Both Elfe and Chippendale had large shops where their employees executed their designs. While they were both excellent craftsmen, they did not spend much time at workbenches as they grew older. Chippendale, in his later years, daily entertained many Londoners with tea and conversation in his showroom.

Elfe was an astute businessman and he spent a lot of his time amassing a fortune: buying, selling and renting Charleston real estate; loaning money and collecting interest; overseeing the maintenance of his properties; and managing his shop.

In 1765, Elfe bought a 234 acre plantation on Daniel's Island, north of Charleston and accessible by the Cooper River. He did not live on this plantation nor operate it as a profit-making, working farm. Instead, he used it as a weekend retreat. He purchased a canoe with sails and a barge with sails to ferry people and produce to and from Charleston, and sold livestock and fruit — probably peaches, plums, and

figs — as well as firewood. The barge may have also been used for delivering furniture to outlying plantations. He owned a plantation at Amelia which he gave to his son William, and a second one on Daniel's Island which he gave to his son George. This plantation later provided a less conspicuous location for his family than right in the heart of Charleston, where his Tory sympathies made life unpleasant.

His loyalist sympathies were like many of the other Charleston merchants such as Nathaniel Russell who was forced to leave town but was re-admitted after the war and later built the impressive Federal style townhouse now open as a museum on Meeting Street.

Elfe's widow Rachel inherited the plantation for her lifetime and soon after his death moved there to stay. In 1781, while the British occupied Charleston, American soldiers plundered Mrs. Elfe's plantation, breaking down the fences and turning horses into the cornfield.

When Rachel died in 1805, the property went to the son, George. The buildings had fallen into ruins or had been destroyed by 1824, but the foundations were re-discovered in the late 1970s when the introduction of deep plowing turned up old bricks, shells and china fragments from the 1760s. These were found in the midst of an area of dark, rich soil, the sign of a former barnyard.

The location of Elfe's workshop is not positively known, although he apparently moved around a lot and may have had more than one shop at the same time. There are references to him operating from several different locations. The *South Carolina Gazette*, on Sept. 28, 1747, mentioned his shop as "near Doct. Martini's," though where that was is not known. In 1748 he was "at the corner opposite Mr. Eycotts..." Again, that location is not known.

In 1763, Elfe sold what may have been 54 Queen Street to Richard Hart, a chairmaker. The house at No. 54 is adjacent to a 20th century furniture store now known as the "Thomas Elfe Workshop." The house itself is believed by some to have been designed or built by Elfe and he may have lived there at one time. The house was included in the Historic American Buildings Survey and, as a result, measured drawings, photos and a description are in the Library of Congress.

There were originally two buildings at No. 54, one behind the other. The rear one could well have been a shop. A question arose over whether street No. 54 was part of lot No. 250 which Elfe sold or lot No. 83 which was John Edward's house.

In 1766, Elfe had apparently not yet moved into the house at Broad and Friend (now Legare), for he placed the following ad in the *South Carolina Gazette:*

"...To be let, and may be entered on directly, A very pleasant, airy, three story house, has three rooms on a floor, with a kitchen, wash-house, stables, and chair-house; situated at the upper end of Broad Street. Enquire of Thomas Elfe."

This "chair-house" apparently became one of his shops, perhaps a small one specializing in chairs, while the larger case pieces were made in the King Street shop.

In 1768, Elfe again advertised the house at the top of Broad Street for rent, even though he was living there. He stated that the house was "opposite to Arthur Middleton, Esq" (*South Carolina Gazette*, 20 June 1768). This is the same person who later signed the Declaration of Independence and to whom he is reputed to have sold a bed which is now in the S.C. Governor's Mansion. The location of Middleton's house was probably where St. John the Baptist Catholic Cathedral now stands.

In 1771, when he ended his partnership with John Fisher, he advertised in the *Gazette* that he would continue operating from his "old shop in Broad Street."

In 1773, Mr. Russell, an upholsterer, advertised that he had taken "apartments at Mr. Elfe's, cabinetmaker in Broad Street, until he can conveniently suit himself with a house proper for his purposes."

In 1775, Thomas Elfe's will indicated that he owned and lived in the same house at Broad and Friend which he had advertised for rent in 1766. He also owned houses at Nos. 2 and 3 Broad Street which he rented, probably as residences but perhaps as businesses since these houses were just opposite the Exchange building. His will also indicated that he had a shop on King Street and a shop on Broad Street which may have been adjacent to his home at Broad and Friend.

Elfe was a member of Charleston's St. Philip's Parish. In 1751, planning began for a new church to stand on the spot where the original St. Philip's had stood at the corner of Meeting and Broad Streets. It would be called St. Michael's and would resemble St. Martins-in-the-Fields at Trafalgar Square in London.

By 1760, while he was actively engaged in the new church's construction, Elfe bought pew No. 14, near the Communion Table (Figure 3). It was advertised in the Charleston *Courier* of January 10, 1805, for sale after his wife's death. That pew may still be seen today.

Humphrey Sommers, who bought Elfe furniture in 1772-73 for his house on Tradd Street (two rooms of which were reproduced at MESDA), was the contractor who installed the slate roof on St. Michael's Church in 1760 while Thomas Elfe was also working there.

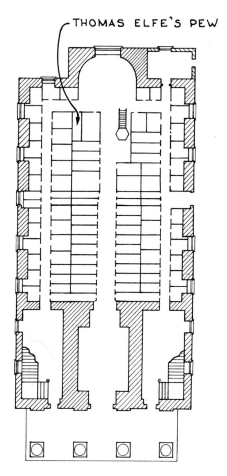

ST. MICHAEL'S CHURCH
Figure 3

During the church construction, Elfe and his then-partner, Hutchinson, submitted bills for balusters on the steeple, balusters and rails for the steps leading to the pulpit (Plate I), and the cornice around the outside of the church. In June, 1760, they submitted a bill for a wooden altar rail and balusters. Later, the church replaced these with a London artisan's wrought iron design. In the fall of 1760, Elfe and Hutchinson hung the heavy, central-west doors (Plate II) with their 15-1/2 ft. long bolt, and in the spring of 1761 they turned the columns and made the capitals (someone else carved them) to support the interior balconies.

In March of 1763, Elfe and Hutchinson made the communion table of rich, Santo Domingo mahogany, finishing it in time for Easter. That communion table survived the Revolution, the shelling, pillage and desecration of the Civil War, hurricanes, and an earthquake until it was replaced in 1892.

Elfe's largest selection of work remaining at St. Michael's lies buried in the adjoining churchyard His coffins were best-sellers and the cedar and cypress ones are probably still there in good condition — all but his, for he is not buried there.

It is not known what caused Elfe's death, where he was buried, or even exactly when he died, there being three different dates listed:

 28 November 1775: Family Bible
 15 December 1775: Haynes Records
 8 December 1775: *South Carolina Gazette*

Thomas Elfe
and Charleston Furniture

Alan Gowan's analysis of American eighteenth century architecture and furniture indicated the classical patterns of development evident in Greek art in the fifth century B.C., again in fifteenth century Renaissance Italy, and in eighteenth century English and American furniture. He recognized four phases of development — appearance, growth, maturity and decline — and identified the eighteenth century styles and times as follows:

PHASE	STYLE	ENGLAND	AMERICA
Appearance	William & Mary	c. 1685-1700	c. 1700-1725
Growth	Queen Anne	c. 1700-1740	c. 1725-1750
Maturity	Chippendale	c. 1740-1765	c. 1750-1785
	Adam, Sheraton		
Decline	Hepplewhite	c. 1765-1810	
	Adam, Federal		c. 1785-1820

Gowan considered the "Maturity" phase, during which Chippendale and Elfe were at work, as the golden age of furniture (Figure 4).

WILLIAM AND MARY QUEEN ANNE CHIPPENDALE HEPPLEWHITE

Figure 4

Elfe listed the following items of furniture which he sold during the 8 years covered by his account book:

Beds	131
Coffins	63
Cribs & Cradles	13
Chairs	677
Double Chests	28
Sofa	9
Dining Tables	132
Card Tables	40
Close Stool Chair	41
Book Cases	16
Dressing Drawers	35
Half Drawers	22
Breakfast & Pembroke Table	39
Tea Tables & Trays	95
Slab Tables	21
Side Boards	18
Clothes Presses	7
Desks	37
Desk & Bookcase	4
Clock Case	4
Miscellaneous	203
	1635 total

The Elfe "body of furniture" may be identified by several common features, the most familiar of which is the famous fret (Figures 5 and 6). The intertwined diamond and figure eight appeared as an extra cost decoration on some of his case work — double chests; desk/bookcases; and library bookcases — always 1 3/16" wide, with a 6 7/8" pattern repeat length. Though no examples are yet known, it was probably also used on bookcases and clothes presses. Another form of it was also used on some pierced-splat chairs and breakfast tables.

All of the diamond and figure eight frets seen on case pieces appear to have been made from a single, basic pattern, suggesting the work of a single shop. The width, thickness, and pattern repeat lengths are all identical. The vine figures of the pattern are all the same width and have square, not rounded, edges. One chest which did have rounded vine edges was easily eliminated and found to be a later work.

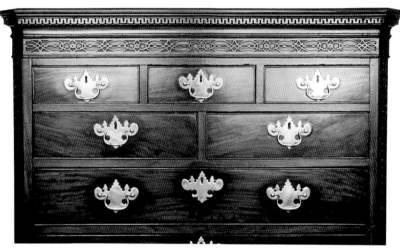

Figure 5

The frets, although of identical central pattern dimensions, appear to have been cut especially for each piece, since the widths of the various case pieces varied. Some had square corners while others had chamfered corner posts. The solution to these variations appears to have been coordinated using the same fret dimensions with different placements. Some pieces had frets which centered on the diamond while others centered on the flower figure between adjoining figure eights. This resulted in the basic piece dimensions all being related, thus creating a "body of furniture." Even the case pieces which did not have frets (and they were in the

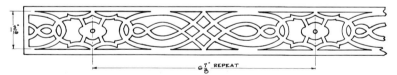

Elfe Fret

Related examples by Chippendale

Figure 6

majority) used the same basic dimensions, proportions and features, and can now start to be related to the other pieces in the "body."

Each fret end was terminated in solid, uncut, unpieced borders at the front corners, requiring custom fitting and ruling out a stockpile of longer lengths of fret. Both open and solid terminations at the rear ends of the side frets were found. This fret does not appear in other American furniture. Elfe charged £5 extra for it on a case piece. Chippendale, coincidentally, used two similar components of this same fret on a mahogany, marble-topped side table (or "slab table") made in 1760-65. That table, made for Hagley Hall, Worchester, is illustrated in the 1925 biography by Oliver Brackett.

The case pieces have very similar ogee bracket feet (Figure 7). Usually less than one inch thick, their wood grain is horizontal and attached to a hidden, vertical corner brace. The base moldings of these case pieces all use a small coved fillet, a taurus and a square base.

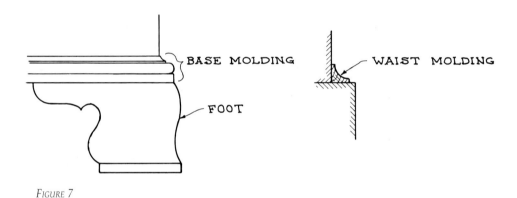

Figure 7

Side-to-side grain was used on the drawer bottoms of large case pieces and a central front-to-rear muntin or cross brace with the bottom halved and supported by grooves in the muntin. This technique was used by some English cabinetmakers, but was not seen often in this country. Details are shown with Mr. Dwight's double chest illustrated in this book.

Mahogany was relatively inexpensive and readily available in Charleston in Elfe's time, due to Charleston's proximity to the mahogany forests of the Caribbean. Sometimes, figured mahogany veneer was used on drawer fronts. Mr. Dwight's double chest is veneered, while the MESDA example included herein used solid mahogany.

All of the drawer fronts used cockbeading, a small molding illustrated on the drawer edges of Mr. Dwight's chest. Some chests, such as the block-fronts made during the same period in Newport by the famous Townsend and Goddard families of cabinetmakers, had beading around the edges of the openings. Others had

drawer fronts with overlapping edges which covered the crack between the drawer and drawer opening. Unlike some other cabinetmakers, those in Charleston fitted their cockbeading into a rabbet extending to the front edge of the dovetails.

Another identifying characteristic may be found in the upper ends of the flutes on some bedposts and pilasters of Charleston origin. They are inverted, resembling a letter "U" with a small incised hole just above each flute. These "U-dots" appear on several chests and beds, inside desks and in the Greek key used on the mantel of the drawing room fireplace of the Heyward-Washington House.

Black, or swamp, cypress was used by many Charleston cabinetmakers as a secondary wood. A softwood, indigenous to the swampy Lowcountry of South Carolina and requiring a rare sequence of drought, shade, and flooding in order to propagate, it is no longer commercially available even in Charleston. This wood was not readily available near any of the other major colonial cities, so it can be used as an identifier of Charleston-made furniture.

Recently, a fine upholstered easy chair at the Metropolitan Museum of Art (Figures 8 and 9), long thought to have been made in New York, was found to have cypress parts in its frame. Along with the existence of two other similarly constructed Charleston chairs, one at Williamsburg and the other at MESDA (included in this book) with an identical pair of "high-shod, spade-footed" rear legs, the use of cypress suggests that the Metropolitan example had been made in Charleston.

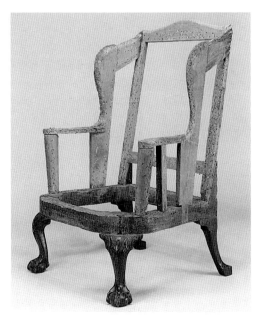

FIGURE 8

FIGURE 9

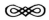

Authenticity and Attribution

Milby Burton was certain that he had correctly attributed a large body of similar Charleston furniture to Thomas Elfe and his workshop. Burton studied old wills, newspaper advertisements, city directories, obituaries, deeds and over 1400 inventories reconstructing eighteenth century events in Charleston. He examined the actual furniture, the Account Book, and he knew the present-day owners.

Burton isolated unique, but common, characteristics such as the fret and other features on the furniture, all indicating a common designer; however, authorities at the Museum of Early Southern Decorative Arts (MESDA) in Winston-Salem, North Carolina, point out that not a single *documented* connection exists between Thomas Elfe and this body of Charleston work. So far, no furniture listed in the Account Book has been traced to a particular antique.

Ironically, MESDA features two reproduction rooms from the Humphrey Sommers house at 128 Tradd Street in Charleston. In the parlor is an exact reproduction of the original mantlepiece by the contemporary carver, John Bivins. In this room and in the bedroom are several pieces of furniture which, until as recently as 1979, were attributed by MESDA to Elfe. Although these pieces are probably not the same ones originally bought for the house, they were obviously acquired to match the Account Book list of furniture which Sommers bought from Elfe:

Nov. 1772 -	*large close [sic] press with pediment head*	
	cutopin [cut open]	*£85*
Dec. 1772 -	*Child's Chair Carved*	*£12*
May 1773 -	*A double chest of drawers with a fret round*	*£80*
	A mahogany bedstead, fluted post & brass	
	caps with a carved cornish [sic]	*£65*
	A lady's dressing drawers for daughter	*£45*
Oct. 1773 -	*A poplar bedstead*	*£6.10*
Nov. 1773-	*A new side to a poplar bedstead*	*£ -15.-*
Dec. 1773 -	*2 new casters on an easy chair*	*£ -15.-*

There were no surviving labels on Elfe furniture, as it was the fashion in London at that time for cabinetmakers to leave their work unsigned and Elfe was London-trained. By 1773, however, John Shaw was labeling his shop's work in Annapolis, Maryland, but only a few labeled pieces from eighteenth century Charleston have been found — none of them by Elfe.

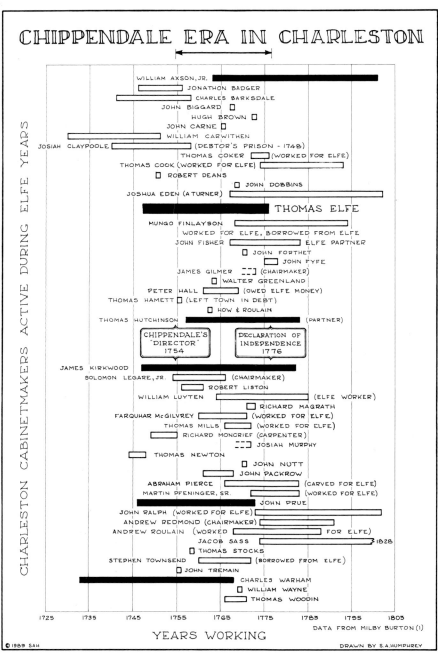

FIGURE 10

No labels are on the over 700 pieces attributed to Chippendale. Though receipts and inventories led to authentication of Chippendale's furniture, none for Elfe furniture have yet been found. The only positively attributable Elfe piece is the Royal Governor's chair detailed in this book. No mention of purchases in a diary have yet been discovered. No trail of wills that lead back to a sale mentioned in the years covered by Elfe's Account Book is known.

Milby Burton wrote that "a few Elfe pieces have been traced through families." That trail is now cold and the pieces and family identities are lost, but it indicates that Burton at one time had what he considered to be solid evidence.

As previously mentioned, Chippendale's *Director* is known to have been for sale in a Charleston store in Elfe's time and the designs were certainly used by others. Other London-trained cabinetmakers who knew of Chippendale's book also worked in Charleston at the time.

A look at the active Charleston cabinetmakers working during the same period as Elfe (1747-1775) reveals that there were over 50 of them (Figure 10). The number 250 is often quoted as the number of cabinetmakers in Charleston, but that number is the total from 1700 to 1825. We may exclude those before him (fewer than 20) as the possible builder of the large, "Elfe body of furniture," since Chippendale style had not yet become popular.

The Declaration of Independence in 1776 — one year after Elfe's death — marked the end of all but a trickle of Charleston-made, Chippendale style furniture. After the war, it was a few years before the wealth it took to sustain a first-rate cabinetmaking industry returned. By then, Hepplewhite, Adam or Federal styles, as well as French styles, became popular. The Chippendale designs were out of style. Even Chippendale himself was preparing a new *Director* with updated styles when he died in 1779.

Many of the fifty Charleston cabinetmakers may be ruled out since they were only active during Elfe's early period while the style was first appearing or because they were specialists (turners, carvers and chair makers). Many of them are known to have worked for Elfe; while they actually contributed to his furniture, they could hardly be considered responsible for it.

Most were only in town for two or three years, hardly enough time to have created the large body of furniture thought to be Elfe's. Only a few could have done it. They were:

THOMAS HUTCHINSON (-1782, active 1757-1782)
WILLIAM AXSON, JR. (1739-1800, active 1763-1800)
JAMES KIRKWOOD (1716-1781, active 1747-1781)
JOHN PRUE (-1772, active 1746-1772)
CHARLES WARHAM (1701-1779, active 1733-1767)

Nothing is known about Kirkwood's, Prue's or Warham's furniture. While one of these five cabinetmakers may have been responsible for the large body of related furniture, this leaves the whereabouts of the furniture listed in Elfe's Account Book and all of the earlier Elfe furniture which the Account Book implies a mystery.

Thomas Hutchinson and Elfe were partners when they made the chairs and tables for the Council Chamber in 1756-58. In 1760-63, they made much of the interior woodwork and the communion table for St. Michael's Church. Later, their partnership dissolved, but they remained friends, although Elfe later had other business partners. Hutchinson was godfather to Thomas Elfe, Jr. and served as one of the executors of Elfe Sr.'s estate.

William Axson, Jr. was highly regarded in Charleston. Where he served his apprenticeship is not known, but he was probably born and trained in Charleston. He was in the militia and fought the British. After the war, he returned to cabinetmaking. A William Axson, along with several other mechanics and the brick supplier, carved their names or initials into the brickwork of Pompion Hill Chapel (1763) on the banks of the East Cooper (Plate III). Axson added a masonic emblem to his marked bricks, leading some to credit him with the brickwork; however, others have noted that a carpenter with that name was also working in the area at the time.

There are two desk-bookcases which, at one time, were attributed to Axson; one now at MESDA and the other in the Nathaniel Russell House in Charleston. Neither has the Elfe fret nor the other features of "Elfe" furniture, casting doubt over whether Axson made the pieces with "Elfe" features; however, inside Pompion Hill's Palladian window is fret trim similar to that on these two desk-bookcases.

Two double chests in the Heyward-Washington house closely match Mr. Gibbs's chest shown later in this book. Likely, these are all standard model, no-special-feature, Charleston double chests. But one of the Heyward-Washington House chests has the initials "WA" (William Axson?) rather crudely carved in its bottom (Plates IV and V). The rest of the bottom is covered with cracks, and the initials *could* be nothing more than a coincidence. Assuming for the moment that they are authentic, they would seem to relate the chest to William Axson, especially since both Pompion Hill Chapel and St. Stephens Chapel have the same "WA" cipher.

If there had been only one example of initials, one might dismiss this curious circumstance as the handiwork of some owner, but those "brandings" usually occur on a drawer, or the back of the piece or in some easier-to-reach location than the bottom of a heavy chest. The "W" and the "A" are run together so that the two letters share a common side, as though this were a trademark. The horizontal bar in the "A" is indistinct and may be only another crack. The overall appearance of the cipher does not match the quality workmanship of the rest of the piece.

Elfe could not possibly have made all of the furniture which he sold, but was undoubtedly using slaves, journeymen and other local cabinetmakers to produce his merchandise. The Account Book has several references to this. As a master, he could require that this furniture match his designs, even though made in another shop, so that he could command the top prices for which his furniture designs sold.

Axson's pride in his workmanship could have led the young man to cut his initials in the remote location and in the form of a trademark on this piece for which another man would take credit. Today, one can only speculate about the initials, but neither the circumstances, nor the quality of the cipher encourage attribution of the "body of furniture" to Axson.

In *American Furniture — 1620 to the Present*, Bates and Fairbanks expressed the opinion that Elfe's fret was "now believed to be a hallmark of Charleston shops in general." This statement is questionable. It suggests that the fret might have been used before or after Elfe's active period, but no examples are known. Variations between cabinetmakers would also have been expected, but all of the diamond and figure eight frets examined herein were identical in form and dimension. While Elfe's Account Book mentioned sales of many pieces of furniture with fret, there were no sales of furniture fret mentioned.

John Fullerton, a carpenter and contractor, built a house in 1772/73 at 15 Legare Street. Elfe sold Fullerton 100 feet of fret in 1773 which is probably that in the cornice and overmantel of the second floor drawing room (Figure 11). It is larger and similar, but not identical, to the furniture fret.

The fret on the Heyward-Washington House (87 Church Street) overmantel and cornice is identical to that in the Fullerton house (Figures 12 and 13). Neither is identical to Elfe's furniture fret, but the fret on either side of the Heyward-Washington House mantel center-piece is a larger, exact match for the furniture fret. John Bivins, formerly of MESDA,

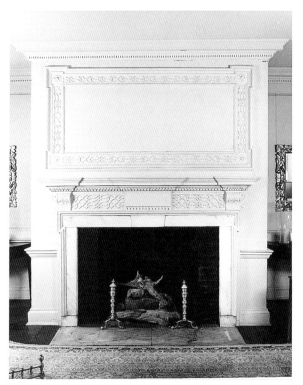

FIGURE 11

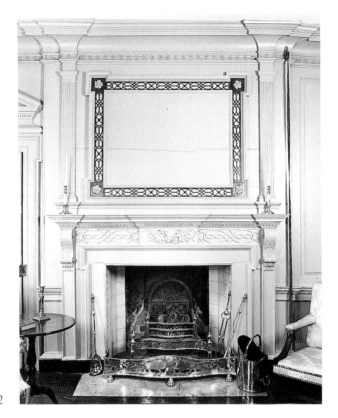

has presented convincing evidence that the carved center-piece of that mantel and the consoles at either end of it are carving-in-the-round from the hands of an unknown carver who did similar work at several other Charleston houses and nearby plantations.

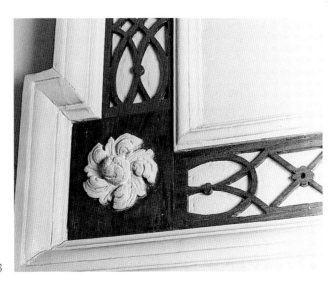

Figure 13

Probably the overwhelming quantity of furniture sales and the fret quantities sold to John Fullerton and listed in the Account book influenced Milby Burton. After seeing the fret on fireplace mantels in Charleston houses owned by Heyward and Fullerton, Burton credited the body of Charleston furniture with similar fret to Elfe. Not a bad assumption, although MESDA has been reluctant to endorse Burton's attribution until more absolute proof appears.

Even Burton may have had reservations about individual attributions, for he neatly avoided assigning any to the illustrations in his book on Charleston furniture. Nevertheless, he did credit Elfe with several identifying devices, such as the diamond and figure-eight fret, the feet on the chests, the moldings, etc. The rest of us will simply have to make up our own minds.

Edwin H. ("Smitty") Smith (1916-1979) was a beloved, respected, twentieth century Charleston cabinetmaker whose papers are now at the South Carolina Historical Society. Among those papers are several patterns of Elfe fret which Smitty had drawn and used to make Elfe copies or adaptations for his customers. He was evidently not aware that all of the antiques had identical frets, for he had made them in several different sizes.

Before his death, several pieces of Smitty's work were brought together for a bicentennial exhibit in Charleston's eighteenth century South Carolina Society Hall. Featured were a pair of magnificent, identical, desk-bookcases; one by Smitty and the other supposedly by Thomas Elfe. The antique belongs to the South Carolina Society (now exhibited on loan in the Nathaniel Russell House) and its fret matches that at Pompion Hill, not the Elfe fret.

A similar desk/bookcase, is at MESDA. The fretwork and the feet of this piece also do not match Elfe's. This does not detract one whit from the beauty of these pieces, but it demonstrates the danger of being "certain" of a fragile attribution. In the meantime, Smitty's work has also become highly prized by local owners and is proudly identified as such in recent Charleston books and house tours.

The mystery of the so-called Elfe body of furniture will continue to challenge researchers. One day, perhaps a single piece of new evidence will fall in place and most of the pieces will be positively attributed to someone. Meanwhile, Elfe's Account Book opens the window to a close-up view of this prolific 18th century Charleston cabinetmaker. The body of furniture, which still awaits positive attribution, remains a delightful collection of fine craftsmanship, elegant design and sound workmanship.

Mr. Dwight's Double Chest

After Henry Ravenel bought this chest-on-chest about 1760, it never left his family. Henry's father was René Louis Ravenel, an early Huguenot who owned Pooshee Plantation, north of Charleston. This plantation, along with several others, was in the area flooded in this century by the creation of Lake Moultrie.

It is believed that Henry, who inherited Pooshee, bought the chest for the plantation and that it made the original journey there, about thirty-seven miles north of Charleston, by barge up the Cooper River (Figure 14). Starting from a Charleston dock, it probably went to the limit of the Cooper's navigable waters near Monck's Corner. From there, it would have been carried the last eight or ten miles by wagon over the primitive roads of the time.

Although this chest was made before the period of the Account Book, on May 3, 1773, Elfe recorded the sale of a similar piece, a "half-drawers" (£35), to the same "Henry Ravinell" [sic] and noted that it was "sent by Watboo John," a trusted slave who must have spent several days to barge this piece up the river. The name "Watboo" probably referred to Wadboo swamp, or Wadboo Barony, another plantation near Ravenel's. Both chests probably spent both the Revolution and the Civil War at Pooshee. The current location of the "half drawers" is not known.

Mr. Henry Ravenel Dwight, Jr., present owner, obtained the double chest through the following provenance:

René Louis Ravenel, first Ravenel to own Pooshee.
Henry Ravenel (1729-1785), married in 1750, purchased chest in 1760.
René Ravenel, (1762-1822)
Dr. Henry Ravenel, (1790-1867)
Rowena Elizabeth Ravenel, (1837-1924)
Henry Ravenel Dwight, Sr., (1873-1961)
Henry Ravenel Dwight, Jr., present owner

There are still several of these chests in Charleston, though not all of them have the distinctive fretwork attributed to Elfe. Elfe's estate inventory listed two "Double-Chests-of-Drawers" in his own house, one with a desk drawer behind the fold-down, top-drawer front of the lower section. Most chests had chamfered corners on the upper half, with five flutes and stopped-flutes.

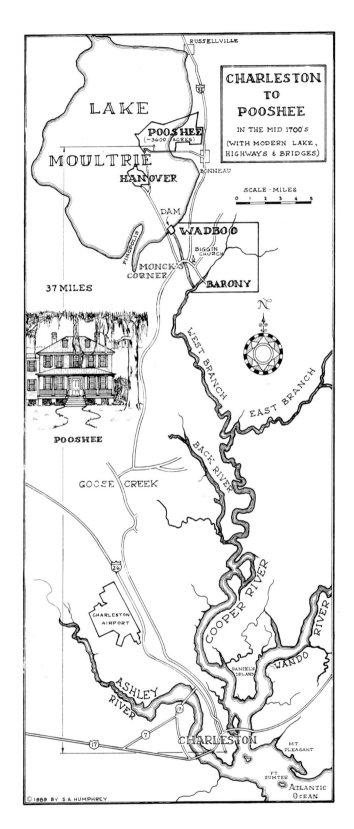

RUSSELLVILLE

LAKE

POOSHEE
(~3600 ACRES)

MOULTRIE

HANOVER

BONNEAU

DAM

PINOPOLIS

WADBOO

BIGGIN CHURCH

MONCK'S CORNER

BARONY

37 MILES

POOSHEE

WEST BRANCH

EAST BRANCH

BACK RIVER

GOOSE CREEK

COOPER RIVER

WANDO RIVER

CHARLESTON AIRPORT

DANIEL'S ISLAND

ASHLEY RIVER

CHARLESTON

MT. PLEASANT

FT. SUMTER

ATLANTIC OCEAN

CHARLESTON
TO
POOSHEE

IN THE MID 1700'S
(WITH MODERN LAKE,
HIGHWAYS & BRIDGES)

SCALE - MILES
0 1 2 3 4 5

© 1989 BY S.A. HUMPHREY

Figure 14

Mr. Dwight's chest is very well made, typical of this group of furniture (Plate VI). Drawer spacer/dust stops have 3/4" thick mahogany facing, are glued (and perhaps tongue and grooved) to a wide, 3/4" cypress board and rest in dadoed grooves in the side walls. They extend about three-fourths of the way to the back, leaving an open vertical space at the rear. The top section of drawers lifts off so that the halves can be easily moved. The cornice is also removable on this particular chest. The fret work and Greek key were both carved separately and applied.

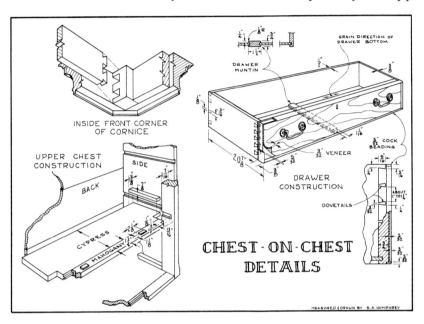

Secondary wood is black cypress, which was inexpensive, strong and durable. Except for drawer fronts, it was used throughout, including the case backs which are horizontally-grained. Elfe used a lot of cypress — even built complete pieces of furniture and coffins of it — but this black cypress is no longer commercially available. Today, cabinetmakers use a lighter cypress, poplar, oak, cedar, or other woods.

Drawer fronts of this piece are veneered with 3/32" figured mahogany, over plain poplar. The beading around the faces of drawer edges is mahogany: rounded, glued and nailed in place, but not covering the dovetails. Elfe used strong dovetails rather than the narrow, fashionable ones of some cabinetmakers. They were irregularly spaced, unlike modern, machine-made ones.

Elfe's drawer bottoms were strengthened by a cross-muntin, dovetailed into the drawer front and rear. The muntins were grooved each side to receive the two halves of the bottom, the grain of which runs from side to side. The grain in some drawer bottoms looks continuous, since both halves were cut from the same piece. Sides and front are grooved to receive the bottom, which is inserted under the rear and nailed to it.

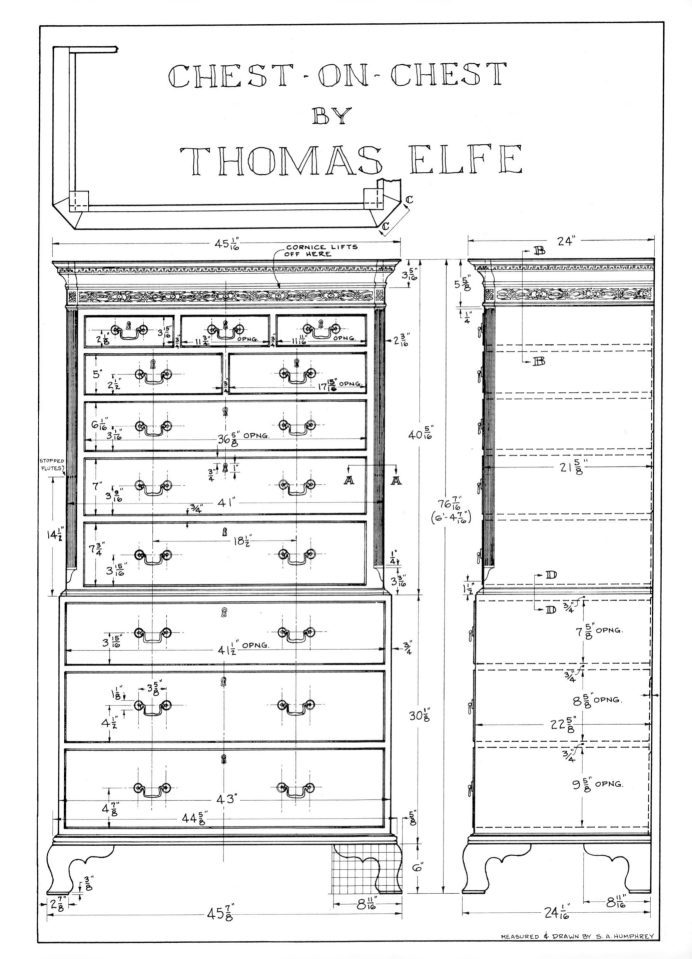

CHEST·ON·CHEST
BY
THOMAS ELFE

CORNICE LIFTS OFF HERE

MEASURED & DRAWN BY S. A. HUMPHREY

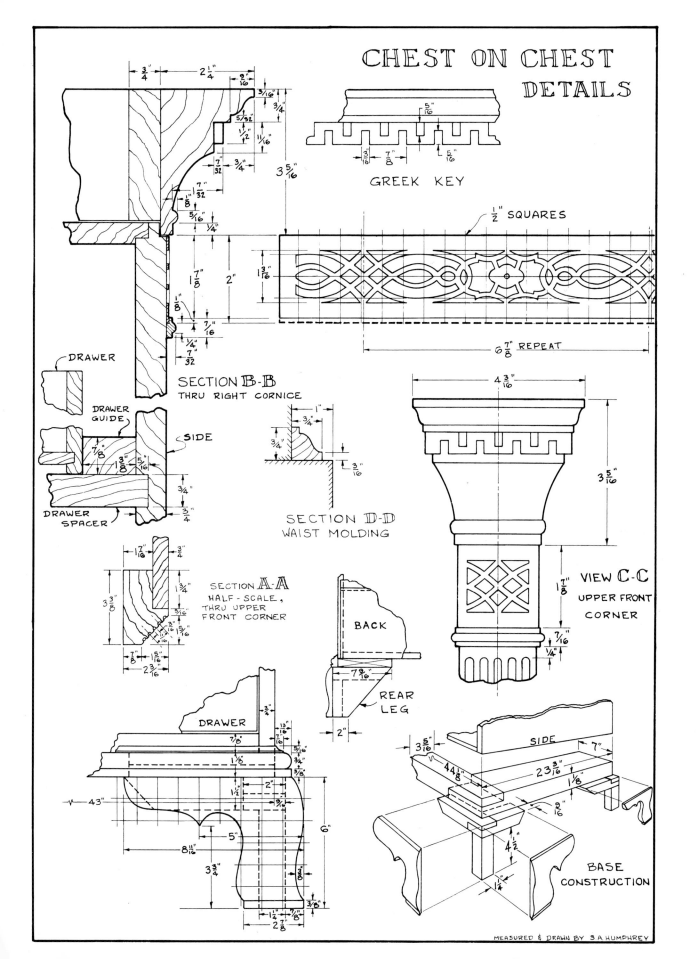

CHEST ON CHEST DETAILS

GREEK KEY

½" SQUARES

6 7/8" REPEAT

SECTION B-B
THRU RIGHT CORNICE

DRAWER

DRAWER GUIDE

SIDE

DRAWER SPACER

SECTION D-D
WAIST MOLDING

SECTION A-A
HALF-SCALE,
THRU UPPER
FRONT CORNER

BACK

REAR LEG

VIEW C-C
UPPER FRONT CORNER

DRAWER

SIDE

BASE CONSTRUCTION

MEASURED & DRAWN BY S.A. HUMPHREY

The Breakfast Tables

There are two of these very similar antique, drop-leaf tables in the Charleston area (Plates VII and VIII). They are beautifully carved and have pierced aprons. One, with leather-wheeled casters, is in the Heyward-Washington House which belongs to the Charleston Museum.

The table's heritage traces through the Lucas, Pinckney, Horry, and Rutledge families of Hampton Plantation. Harriott, the daughter of Eliza Lucas Pinckney, the remarkable lady who helped introduce indigo as an important South Carolina crop, married Daniel Horry of Hampton. Their daughter, also named Harriott, married Frederick Rutledge, and Hampton stayed in the family until they gave the plantation to the state in this century. Located on the Santee River, it is about thirty-five miles northeast of Charleston.

The table may actually have been at Hampton when George Washington stopped there to visit Eliza and her daughter on his 1791 trip. Just when the table left the family is not known, but it was purchased by the Museum in 1952 from Mrs. Frances B. Stewart.

The molded edges and the thin top seem to be forerunners of the more refined Hepplewhite designs to come later, evidence of the swifter transfer of English fashions to Charleston than to the northern colonies. John Shaw's shop, a leader in Annapolis, was not making tables with similar tops until the mid-1780s.

Chippendale called this design a breakfast table, first showing it as *Plate XXXIII* in the first (1754) edition of the *Director* (Figure 15). With a mid-section more nearly square than most Pembroke tables, the leaves are gracefully butterfly-shaped, rather than having the more plain shapes of the Pembroke.

The second possible Elfe breakfast table in the Charleston area is at Middleton Place. Its whereabouts before the Civil War are not clear. Most of the furnishings of that house were either looted or destroyed by Sherman's troops, although some were saved or returned. The table is believed to have been brought there later by a family member, although its design is clearly contemporary with the Charleston Museum's table. Burton connected both tables to Elfe by their diamond and figure-eight carved ends (Figure 16) and Elfe's Account Book listing of "carved end breakfast tables."

At first glance the two tables seem alike, but a closer look reveals subtle differences (Figures 17 and 18). The table at Middleton has no casters, but only because

they were removed; holes still remain. Edges of the top are molded almost in reverse, and stretchers and aprons are not the same. Like the two Dressing Drawers shown herein, these tables have nearly the same dimensions and one may have been constructed from memory of the other, or have been made by a different worker.

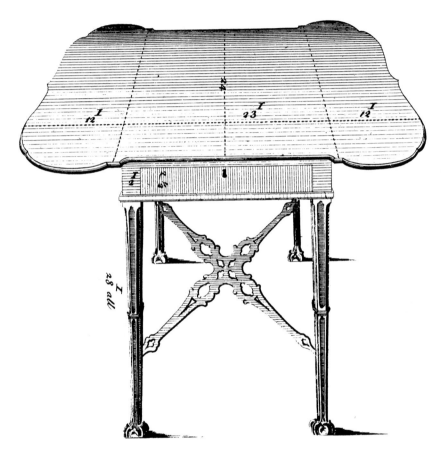

Figure 15

A lot of craftsmen make the central tops of drop-leaf tables too narrow. With age, the tops shrink and the leaves are forced to hang out at an angle, or the tops develop a split down the middle. This can also occur when no movement is allowed to compensate for top shrinkage, opposing the grain direction of the apron ends. Dimensions of the tops in the measured drawings have been shown slightly wider so that reproductions may avoid the leaves being forced outward. Top-split-

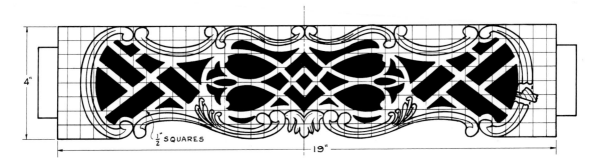

Figure 16

ting may be avoided by attaching the central top with screws having large enough clearance holes or slots in the frame to permit relative movement. As little as 1/16" is sufficient.

Both tables have "rule joints," as the hinged joints of the drop leaves are known. These cover the hinges in such a way that neither the hinge nor the gap between the top and the leaves may be seen. It is a difficult joint to construct in a thin table-top because the buried knuckles of the hinges have such thin cover. The hinges are iron, not brass, for they are not meant to be seen. Table hinges, as they are known, have one side longer than the other so as to accommodate rule joints. Ball & Ball and other hardware manufacturers still sell these hinges.

Other cabinetmakers found Chippendale's breakfast table design popular. Tables with similar stretchers are at the White House, in the State Department's Diplomatic Reception Rooms, at Winterthur Museum, and there is one from the Townsend/Goddard school at the Hunter House in Newport, Rhode Island.

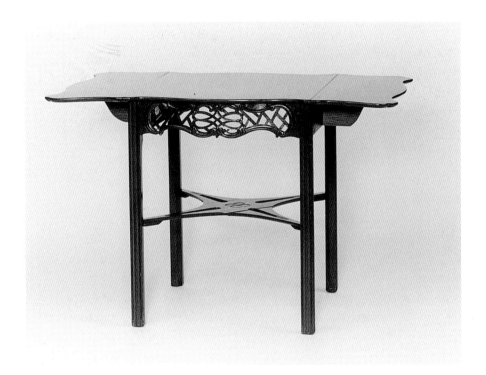

FIGURE 17

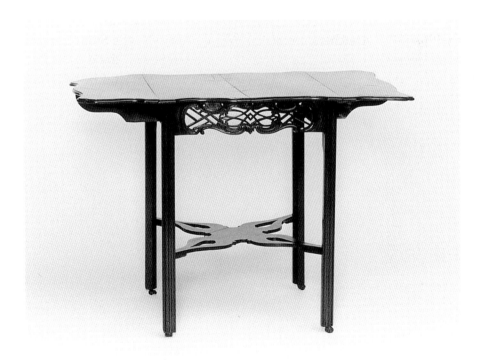

FIGURE 18

THE RUTLEDGE FAMILY
BREAKFAST TABLE
HEYWARD - WASHINGTON HOUSE - CHARLESTON MUSEUM

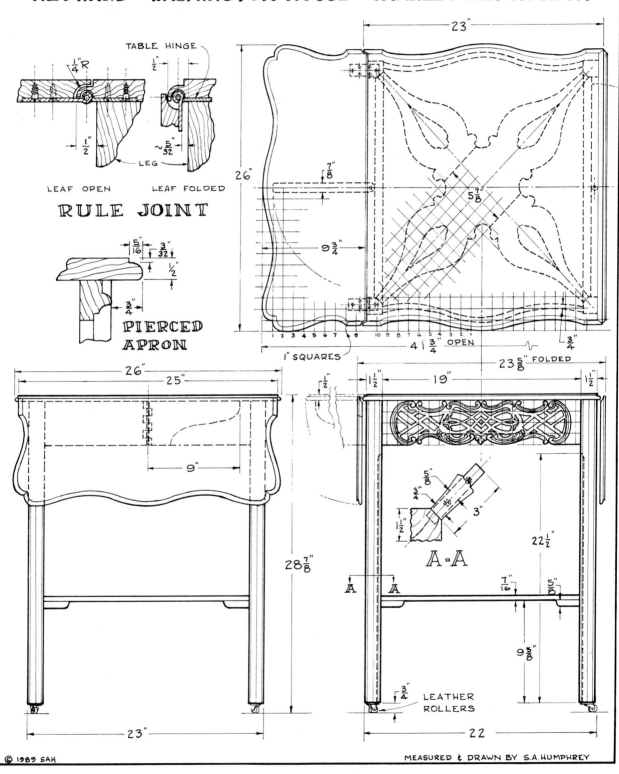

RULE JOINT

LEAF OPEN LEAF FOLDED

TABLE HINGE

LEG

PIERCED APRON

1" SQUARES

MEASURED & DRAWN BY S.A.HUMPHREY

LEATHER ROLLERS

A-A

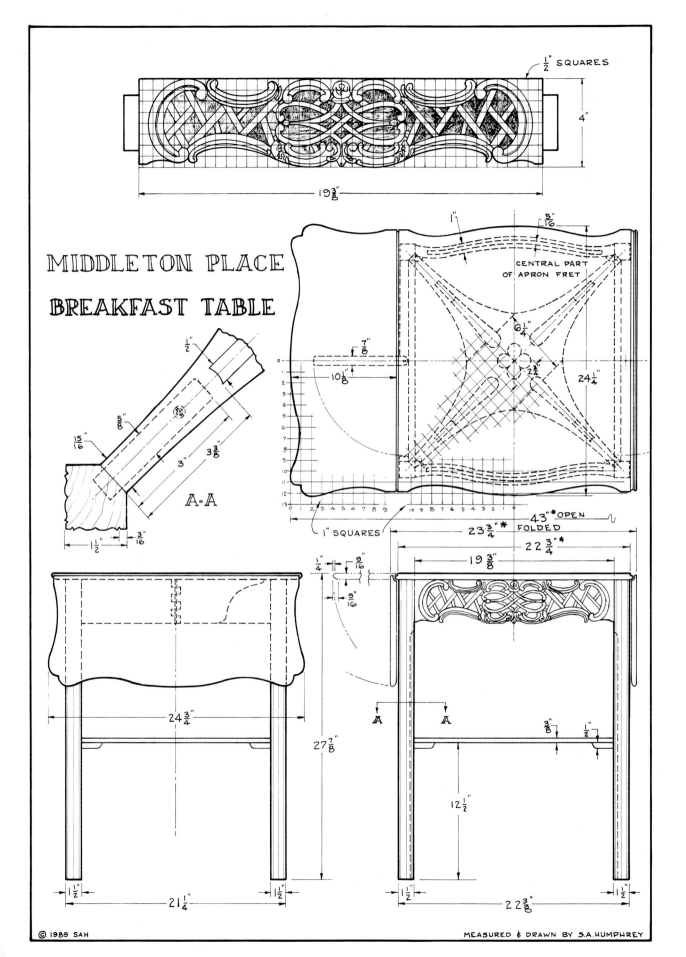

MIDDLETON PLACE
BREAKFAST TABLE

½" SQUARES

19⅜"

4"

1"

5/16"

CENTRAL PART
OF APRON FRET

6¼"

2¾"

24¼"

7/8"

10⅛"

1" SQUARES

43"* OPEN

23¾"* FOLDED

22¾"*

19⅜"

¼"

9/16"

9/16"

A·A

15/16"

⊘ 5/8"

3"

3⅜"

1½"

3/16"

24¾"

27⅞"

A A

3/8" 1½"

12½"

1½" 1½"

21¼"

22⅜"

MEASURED & DRAWN BY S.A. HUMPHREY

Pierced Splat Chair

Because of their uses, many things happen to chairs. They wear out, come unglued, break, get thrown out, get caught in fires and wars, or placed in an attic or shed. So one probably would not expect many Charleston chairs to have survived. But Elfe sold so many — over 600 chairs in just the five years covered in the Account Book — that he must have sold a few thousand in the twenty-eight years he was in Charleston. Surely some of them must have survived. But without labels or other identification, hardly any have been identified as Elfe's.

According to the Account Book, he made three types of straight back chairs: scroll backs (£85 or £90 per dozen), splat backs (£160 per dozen) and carved backs (£230 per dozen). The demand was brisk. Often a home would have thirty to forty chairs and the larger homes had as many as fifty to sixty. Some craftsmen dealt only in chairs, some exclusively in Windsor chairs.

Two splat-back side chairs from Charleston have been found with characteristics that suggest they were from Elfe (Plate IX). They were presented to the Charleston Museum by Luke Vincent Lockwood, author of *Colonial Furniture in America*, and Mrs. Lockwood.

The chairs once belonged to the Baker family who had owned Archdale Hall, a plantation which was located on the east side of the Ashley River just south of Summerville. The central structure was destroyed by the 1886 earthquake, but the family saved the chairs, finally selling them in 1962.

These chairs are rounded on the back of the splat elements, the crest rail, and the upper chair stiles. Chamfers appear on the inner corners of the front legs, and a bead cut by a scratch plane is on the outer, front corners. In Burton's book, he noted that corner brackets were missing from the chairs. Indeed, the accompanying photograph in his book shows light areas on the legs where front and side brackets of about 1/2" x 3" once stood. There is no trace of these light areas on the chairs now, probably owing to later refinishing, which has also rubbed away much of the gilding that appeared in earlier photos.

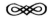

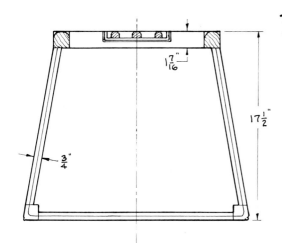

PIERCED SPLAT
SIDE CHAIR
FROM
ARCHDALE HALL

NOW IN HEYWARD WASHINGTON
HOUSE – CHARLESTON MUSEUM

1" SQUARES

GILDED ON FRONT

BACKS ONLY OF CREST RAIL, UPPER STILES & SPLAT ELEMENTS ALL ROUNDED.

A·A

MEASURED & DRAWN BY S.A.HUMPHREY

COLOR PLATES

PLATE *I*

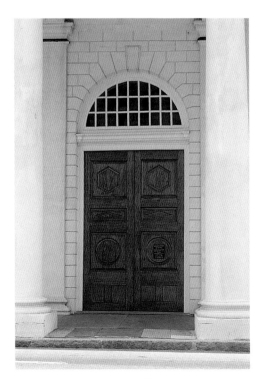

PLATE *II*

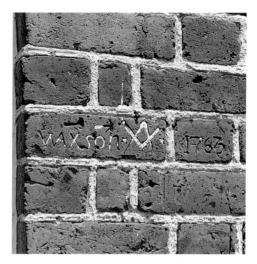

PLATE *III*

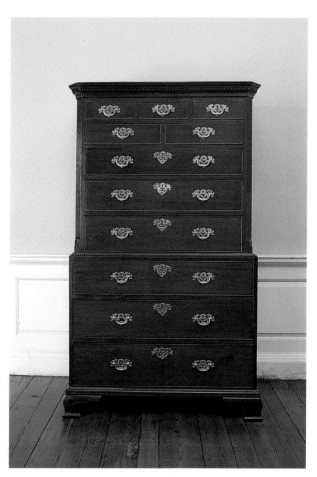

PLATE *IV*

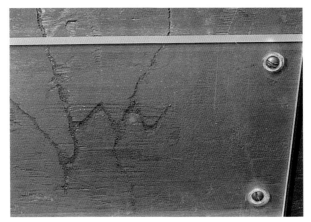

PLATE *V*

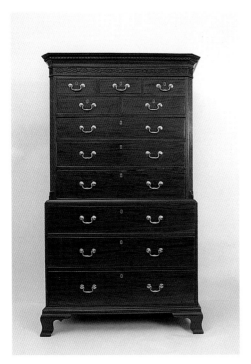

PLATE *VI*

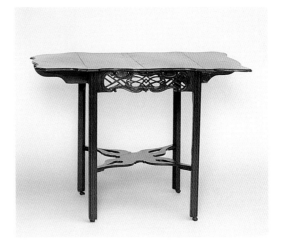

PLATE *VII*

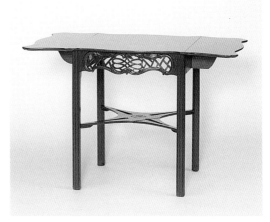

PLATE *VIII*

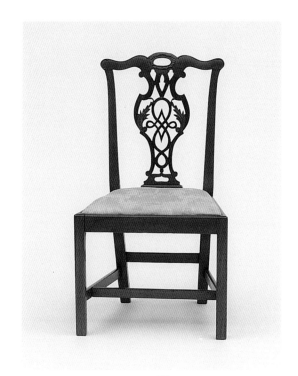

PLATE IX

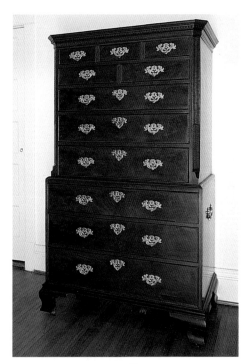

PLATE X

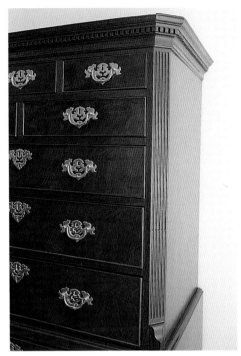

PLATE XI

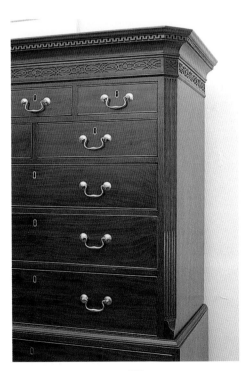

PLATE XII

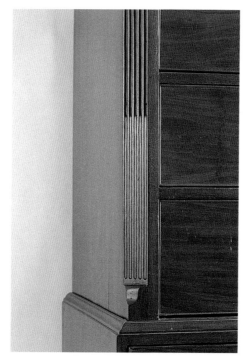

PLATE *XIII*

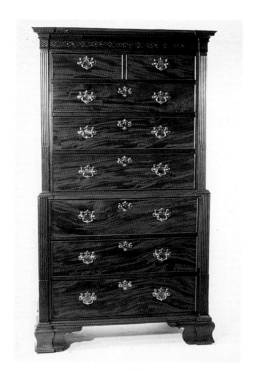

PLATE *XIV*

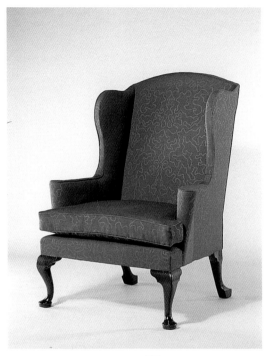

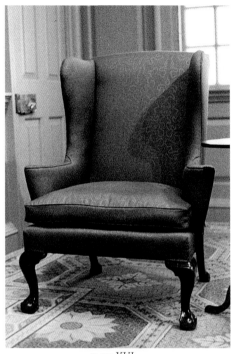

PLATE XV

PLATE XVI

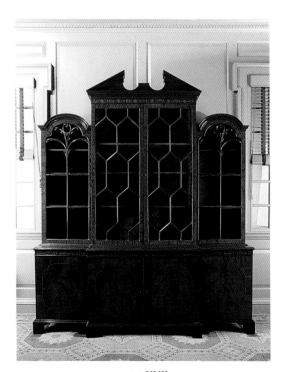

PLATE XVII

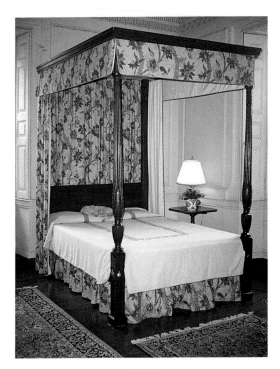

PLATE *XVIII*

PLATE *XIX*

James Gibbs's Double Chest

During his lifetime, Thomas Elfe probably sold at least a hundred double chests of drawers. The list of the 28 double chests mentioned in the Account Book (counting Peter Le Poole's chest *mended* in June 1773) reveals that 19 of them were plain, double chests of drawers. Only 7 of the chests had pediments or desk drawers and only 2 specifically had "frett," although most of the more elaborate chests probably had frets as well.

Many people, however, believe that the chest with a fret was a basic model. Nevertheless, most of Elfe's double chests listed in the Account Book were basic, stripped-down versions. Mr. James Gibbs of Charleston has one of these fretless double chests, in splendid condition (Plate X).

There is no way of knowing whether Mr. Gibbs's chest was one of the 19 standard models in this list, but there is no question that it is part of the overall body of Charleston work. It has the same features which characterize the others: the shape of the feet, the base and waist moldings, the muntin brace with the side-to-side grain in the drawer bottoms, and the cockbeading design on the drawers. It has veneered drawer fronts.

Probably the most striking similarity may be noted between the fluting on the chamfered, upper front corners of this chest (Plate XI) and the exactly matching fluting on Mr. Dwight's chest (Plate XII). Both have 5 flutes and stopped-flutes which start the same distance below the upper molding. The stopped-flutes terminate at the same exact position next to the second drawer (Plate XIII). The "lamb's tongues" at the base of the flutes are identical. As Milby Burton said when he saw it, "This is one of them".

There is another chest like it in the Miles Brewton House which has never passed out of the hands of Miles Brewton's descendants. Two more examples like it are in the Heyward-Washington House. One of those was found in Georgia with what could be William Axson, Jr.'s mark on its bottom and, if so, is believed by this author to be one that Axson built on contract for Elfe, to Elfe's designs, and to be sold in Elfe's showroom.

The early history of this chest is not known, except that it had descended in the Martin family to Dr. John Bachman who married a Martin. Next it went to his daughter Catherine, from whom it descended to her niece (Mrs. Gibbs), and then to her son (James Gibbs, the present owner).

THE 28 DOUBLE CHESTS IN ELFE'S ACCOUNT BOOK

1.	12 Jan 68	Richard Capers	Double Chest Of Drawers	£ 75
2.	20 Sep 71	Francis Young	Mahogany Double Chest Of Drawers	75
3.	26 Nov 71	Mary Waring (Widow)	"Doble [sic] Chest Of Draws With A Pediment Head Cut Through"	82
4.	21 Mar 72	Peter Bonnethon	"Doble [sic] Chest Of Draws"	70
5.	3 Jun 72	?	"Doble [sic] Chest Of Draws"	80
6.	7 Sep 72	John Gaillard	Double Chest Of Drawers	75
7.	30 Sep 72	Richard Salter	"Doble [sic] Chest Of Draws"	75
8.	3 Nov 72	Rawlins Loundes	"Doble [sic] Chest Of Draws W A Pediment Head Cut Thru	85
9.	30 Nov 72	Mary Broughton	"Dble Chest Drawers, W A Desk Drwr	95
10.	16 Apr 73	William Mason	Double Chest Of Drawers	75
11.	6 May 73	Humphrey Sommers	Double Chest Of Drawers With A Frett Round	80
12.	17 May 73	Daniel Hayward	Double Chest Of Drawers	90
13.	18 May 73	Edmund Petrie	Double Chest Of Drawers	75
14.	20 Jun 73	Thomas Farr	Double Chest Of Drawers Desk Draw Top Of Bottom	100
15.	21 Jun 73	Peter Le Poole	Mend A Double Chest Of Drawers	4
16.	22 Jun 73	James Smith	Double Chest Of Drawers W A Frett	80
17.	6 Sep 73	John Gaillard	Double Chest Of Drawers	75
18.	9 Oct 73	John Freer John's Island	Double Chest Of Drawers	75
19.	27 Nov 73	David Gaillard	Double Chest Of Drawers	75
20.	15 Jan 74	Sarah Waring (Widow Of Benj)	Double Chest Of Drawers With A Pediment Head	85
21.	17 Mar 74	Robert Miles	Double Chest Of Drawers With Pediment Head	85
22.	29 Aug 74	Theodore Gaillard	Double Chest Of Drawers For JN Detart	75
23.	8 Sep 74	Thomas Doughty	Double Chest Of Drawers	75
24.	22 Oct 74	William Burrows	Large Double Chest Of Drawers	80.15
25.	1 Dec 74	Benjamin Waring	Double Chest Of Drawers Desk Drawers And Casters	100
26.	3 Dec 74	John Stewart	Double Chest Of Drawers	75
27.	13 Apr 75	Theodore Tresvant	Double Chest Of Drawers	80
28.	24 May 75	James Black	Double Chest Of Drawers	75

THE STANDARD
DOUBLE CHEST

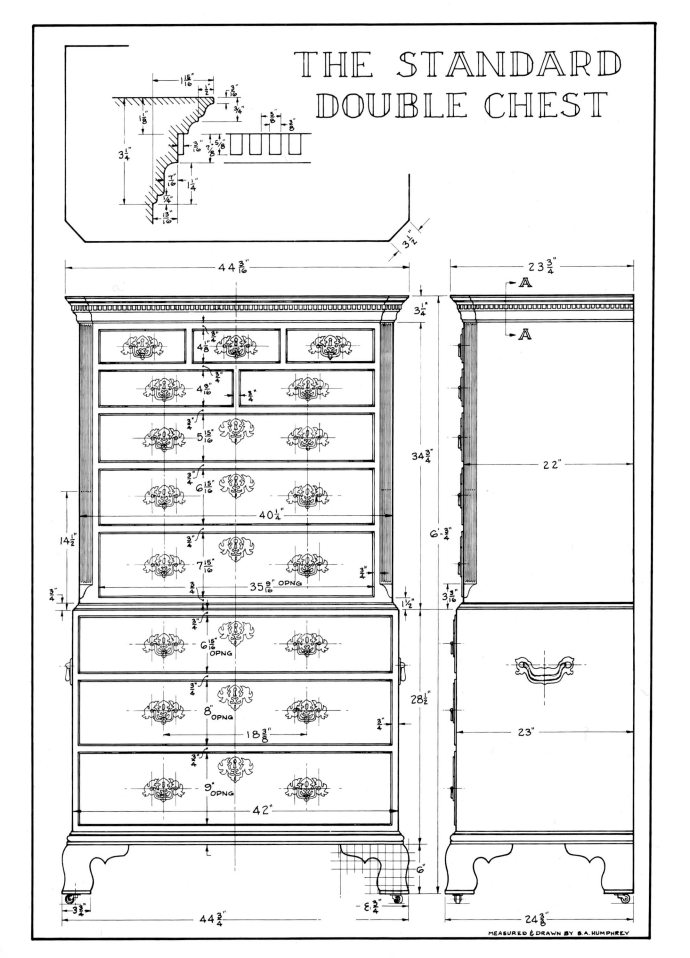

MEASURED & DRAWN BY S.A. HUMPHREY

Governor's Chair

South Carolina's Royal Governor regularly sat in this chair (Figure 19). Colonial Assembly records show that it was ordered from the firm of Elfe and Hutchinson in 1756. First placed in the new State House on the northwest corner of Meeting and Broad Streets in Charleston, it is the only piece of Charleston furniture solidly attributed to Elfe.

The Colonial State House cornerstone was laid by Governor James Glen in 1753. In 1786, the new State Assembly voted to move the capital to Columbia, but two years later, before they could move, the building burned. State records, the ceremonial mace and this chair were rescued from the flames and the mace is still in the State House of Representatives. When the state government moved to new quarters in Columbia, they took the Governor's Chair along.

At about the same time (1755), another Governor's chair was being built for the Virginia capitol at Williamsburg (Figure 20). Like the Charleston chair, this one also changed homes when Virginia moved its capitol to Richmond in 1780. These two are the only Royal Governor's chairs which are known to have survived, although similar ceremonial chairs of the period may be seen in Masonic Lodges and as royal thrones in other countries.

Bradford L. Rauschenberg, of MESDA, meticulously researched the history of the Charleston chair, tracing it to Columbia, where it apparently was set aside after becoming worn and falling out of style. It next appeared in 1856, just 100 years after it was built, as a gift to what is now the University of South Carolina's McKissick Museum. It was a gift from William C. Preston, former college president, United States Senator, and South Carolina State Legislator. He had apparently kept it after it was no longer used in the State Capitol.

The Charleston chair was restored in 1905 for the centennial celebration of the University of South Carolina. A 1903 photo of the chair before its restoration appeared in N. Hudson Moore's *The Old Furniture Book*, and revealed that it originally had horsehair upholstery, a fringe of about 4", and brass upholstery nails.

It was in dilapidated condition in 1903 (Figure 21), missing an arm, several knee brackets from the legs, and what had probably been the Royal crest from the upper rail (Figure 22). Mortises where the crest was attached remain on the back; the crest was probably removed and destroyed when the British left Charleston in 1782. (The crest shown in the drawing is conjectural, based on surviving crests.)

A photograph in Milby Burton's 1955 book showed leather upholstery with brass nails, while Rauschenburg's 1980 study photograph showed it with fabric and gimp as it is today. There was no fringe on either of these re-upholsterings. The Williamsburg chair is restored with fringe, perhaps based on the 1903 photo of the South Carolina chair.

The South Carolina chair was loaned to Charleston, where it appeared at the Old Town Plantation Tricentennial in 1970 and later at the Charleston Museum. It was returned to Columbia and is now on exhibit there in the new State Museum. A reproduction is still on view in Charleston in the Exchange Building.

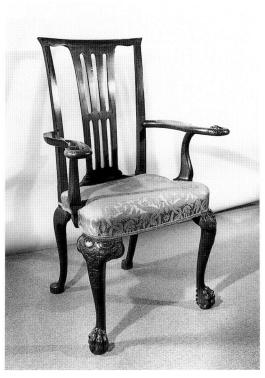

FIGURE 19

The Williamsburg chair remained at the capitol in Richmond until it was given to a janitor in the 1920s. It was later discovered by Dr. Goodwin, rector of Bruton Parish Church in Williamsburg. In 1926, he persuaded John D. Rockefeller, Jr. to rescue and restore what was left of the eighteenth century city of Williamsburg. They purchased the chair in 1927 and it may be seen in Williamsburg today in the DeWitt Wallace Decorative Arts Gallery.

Carving on the South Carolina chair is not deep but rather lightly incised, suggesting an early style and probably an older man than Elfe doing the actual carving; perhaps it was Thomas Hutchinson. Rauschenberg noted that the eagle's head motif gave way to lion's head arm terminals in English furniture by 1735. He also noted in his 1980 study that the Williamsburg chair, with its lion's head arm terminals, served as the prototype for the several other similar Virginia ceremonial chairs. Colonial Williamsburg attributes their Royal Chair to the Anthony Hay shop. They point to completion of their new Capitol in the mid-1750s and to the employment by Hay at that time of London carver James Wilson, who could have accounted for the "well carved lion's heads and feet and acanthus leaves."

The South Carolina chair is an unusual size: height 53 3/8", without crest; width 37 5/8"; and seat height 25". Ordinary chairs have a seat height of 17", but

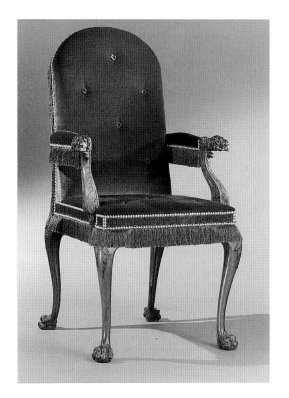

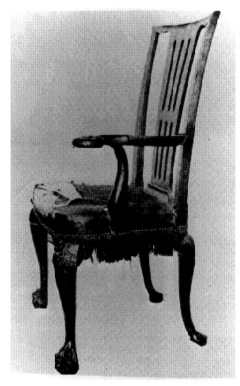

FIGURE 20

FIGURE 21

this one was intended for ceremonial use, with its important occupant elevated above other persons.

Other ceremonial chairs of this period such as the Williamsburg chair and the George III Throne, also had 25″ seat heights and used stools. George III's throne and footstool still survive. The Williamsburg stool is a reproduction based on the proportions of the George III footstool.

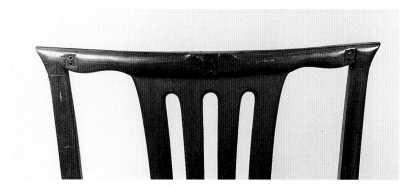

FIGURE 22

ROYAL GOVERNOR'S CHAIR
BY
ELFE & HUTCHINSON
1756 - 8

SURVIVING
CREST
MOUNTING
PADS

DIEU ET MON DROIT

$26\frac{1}{4}$"

$12\frac{1}{8}$

$37\frac{3}{4}$"

$20\frac{7}{8}$"

$8\frac{1}{2}$"

$18\frac{1}{2}$"

25"

34"

22"

3"

$28\frac{3}{8}$"

$6\frac{1}{4}$"

20"

$53\frac{1}{2}$"

8"

FRINGE

4"

$19\frac{5}{8}$"

$20\frac{1}{8}$"

2" SQUARES

$26\frac{1}{2}$"

ROYAL CREST SHOWN IS
CONJECTURAL. ORIGINAL
MOUNTING HOLES REMAIN.

MEASURED & DRAWN BY S.A. HUMPHREY

MESDA Double Chest

T his chest (Plate XIV) is a collection of mysteries. Like Mr. Dwight's chest, it has the same features: the familiar fret, the Greek key, the moldings, mahogany primary and cypress secondary woods, muntins in the wide drawer bottoms, use of flutes and stopped-flutes, beading around the drawer fronts and a double form of the standard foot. There is no record of when it was built or for whom, but, amazingly, it is similar to a design which appears in George Hepplewhite's *The Cabinet Maker and Upholsterer's Guide* (Figure 23) which did not appear until 1788, thirteen years after Elfe's death!

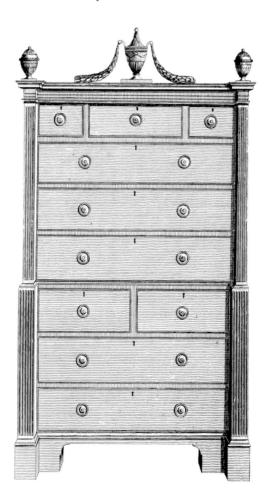

FIGURE 23

MESDA
DOUBLE CHEST

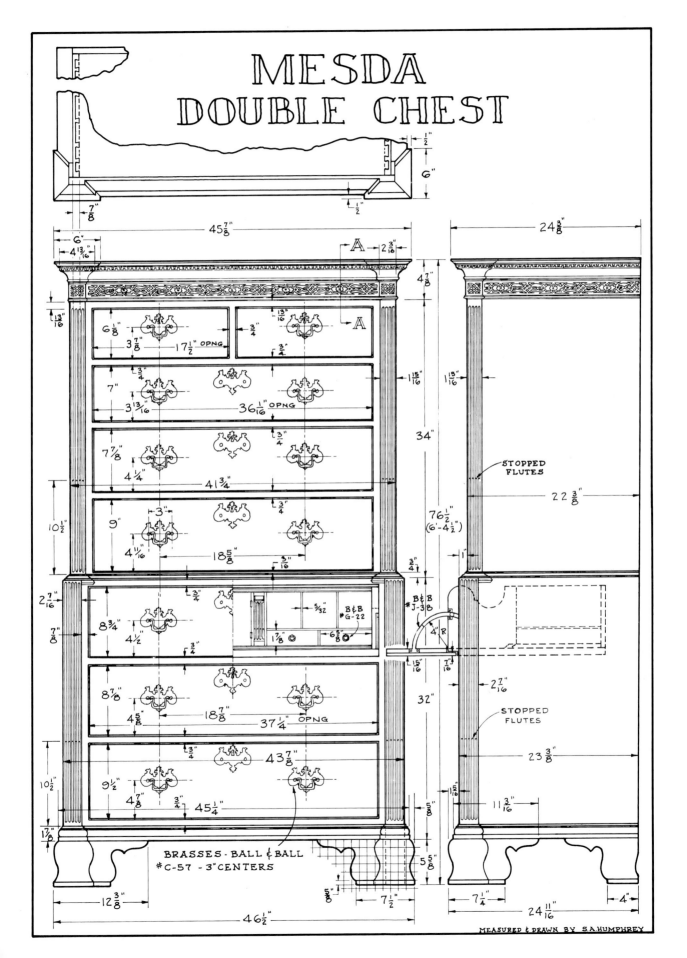

BRASSES · BALL & BALL
#C-57 - 3" CENTERS

STOPPED FLUTES

STOPPED FLUTES

MEASURED & DRAWN BY S.A. HUMPHREY

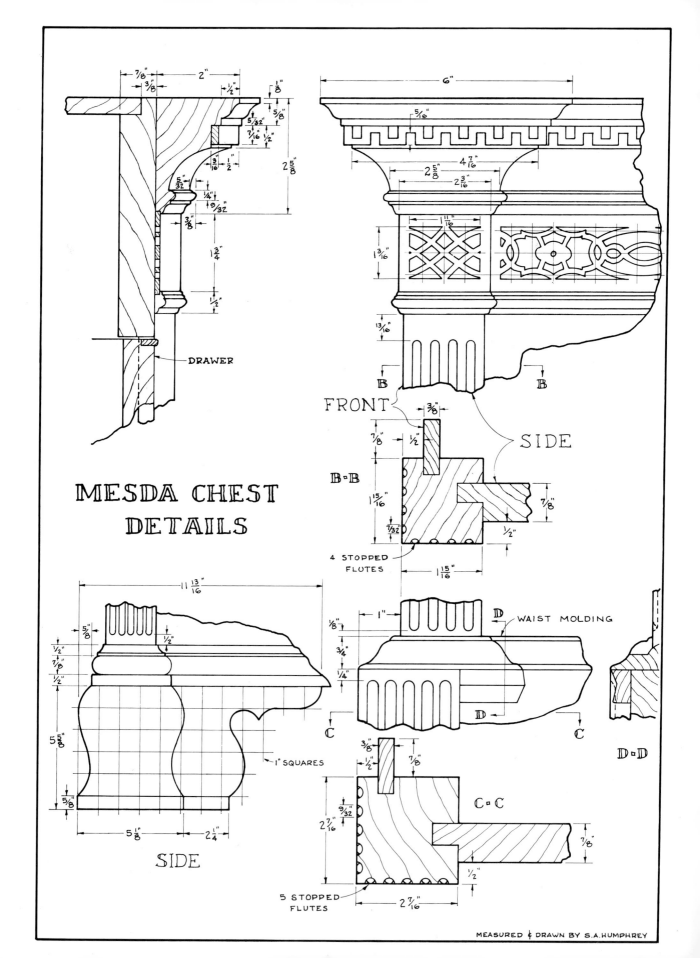

DRAWER

MESDA CHEST
DETAILS

FRONT

SIDE

B-B

4 STOPPED
FLUTES

WAIST MOLDING

D-D

SIDE

1" SQUARES

C-C

5 STOPPED
FLUTES

MEASURED & DRAWN BY S.A.HUMPHREY

Hepplewhite is known more as an English chronicler of others' designs than of his own, so it is remotely possible that he or someone else may have seen this piece before the drawing was made, or that both this chest and Hepplewhite's drawing were both adapted from another piece of furniture made by some other cabinet-maker. Nothing is known of Hepplewhite's life except that he died in 1786. His principle legacy to his wife was a group of furniture drawings which she successfully published as his *Guide*.

There are certain features of this piece of furniture which are of special interest. For example, the transition between the upper and lower pilasters of the chest is handled rather awkwardly by a small molding. In the later, Hepplewhite design the waist molding is narrower and the lower pilaster is wider, eliminating the need for the balancing molding.

Construction of the cornice is unique because of the sides and caps of the pilasters. It took the builder extra trouble to insert the separate pieces which avoid exposing end grain in the large cove of the cornice. Drawer fronts of this chest are of solid, beautifully figured mahogany. Some of the other chests have veneered drawer fronts.

The brasses appear to be replacements. In fact, there are ghost marks on the drawers which suggest that at one time, drawer handles similar to those of the Hepplewhite chest may have been used, although they were off center with the present handles.

Today the double chest stands in MESDA's Humphrey-Sommers reproduction bedroom along with several other pieces similar to those Sommers purchased from Elfe in 1772-73. The diamond and figure eight fret on this chest exactly matches that on Mr. Dwight's Chest, on the Library/Bookcase also at MESDA, on the Sinkler Chest and on the "Mystery Chest." They are all 1 3/16" wide, with a 6 7/8" repeat.

Charleston Queen Anne Easy Chair

Although there is no known connection between Thomas Elfe and this chair (Plate XV), which is now in the Humphrey Sommers parlor at MESDA, it was made in Charleston during Elfe's active period and he could have made it. The chair shows the distinctive Charleston feature of large rear feet (Figure 24) along with Queen Anne front legs. Eagle claw feet were becoming more stylish about the time Elfe arrived in Charleston. The chair has mahogany legs and corner blocks, ash seat rails, poplar arm cones and a cypress frame.

There is another chair with almost identical interior construction, identical rear feet and eagle claw feet with carved knees in the Metropolitan Museum. Long

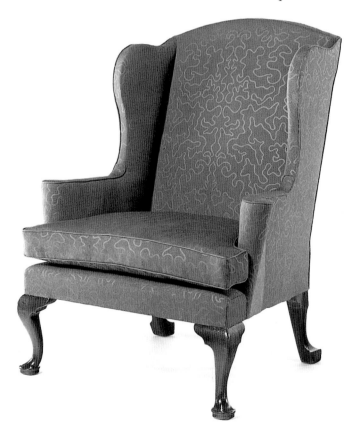

Figure 24

CHARLESTON EASY CHAIR 1735-1745
(MESDA)

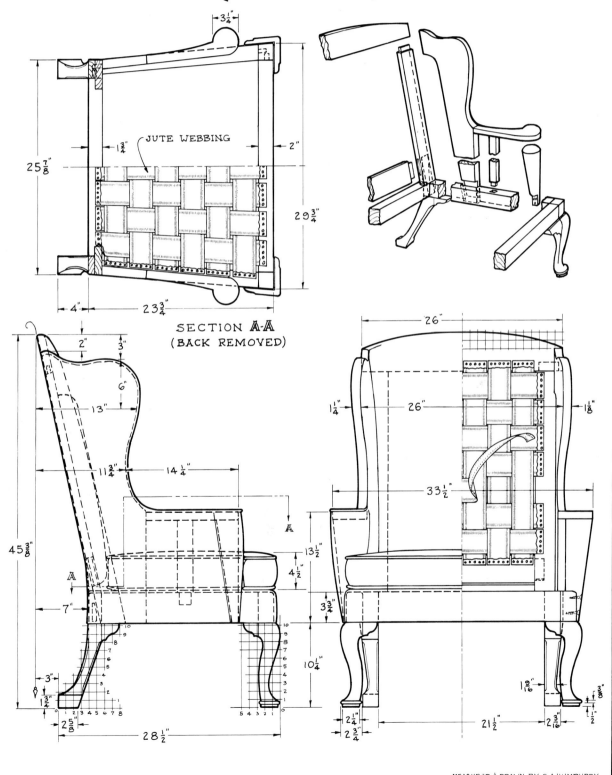

JUTE WEBBING

SECTION A-A
(BACK REMOVED)

MEASURED & DRAWN BY S.A. HUMPHREY

thought to be a New York chair, it has similar primary and secondary woods, which confirms its Charleston heritage. Another with eagle claw feet, similar construction and southern secondary woods is in the Williamsburg collection.

This Queen Anne Chair has a history of descent in the Cannon and Fraser families of Charleston. Daniel Cannon (1726-1802), a master builder who first owned the chair, built two lumber mills just north of Harleston Village (in Charleston) and developed the Village under the name of Cannonsborough after the Revolution. Charles Fraser (1782-1860) became well known as a painter of miniatures. His relative, John Fraser, was the leading blockade runner of the Confederacy during the Civil War.

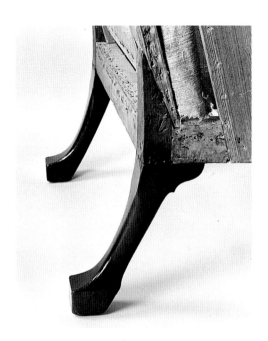

FIGURE 25

The easy chair form originated in England about 1660 and was introduced to the colonies about 1720. Elfe's account book lists several sales of easy chairs. He also mentioned seven different upholsterers with whom he dealt. He built frames for others, and had his frames upholstered both in his own shop and in outside shops.

A detail of the rear foot may be seen in Figure 25.

Easy chairs built in this period were first covered with interwoven widths of jute webbing stretched and nailed over the tops of the seat rails and back rails. When coil seat springs were adopted in the 19th century, the jute webbing was dropped to the bottom of the seat rails and coil springs were tied in place over them. Burlap or sacking was then placed over the springs.

Under the final upholstery material the stuffing was most often horsehair, which was considered best. Sometimes cattle hair, moss or sea weed stuffing was used. Hair cloth, made of horse hair woven with wool, linen or cotton was then used for the final cover as well as other fine fabrics. The loose cushions were usually stuffed with feathers. Goose down feathers were the most luxurious, providing an elegant "mashed in comfort" look after someone sits in the chair.

[*Cabinetmaker note*: A reproduction of this chair may be more comfortable about 2" less wide and 2" less deep. Also a few steel straps concealed at stress points on the frame will prevent future problems.]

Charleston Ball and Claw Foot
Easy Chair 1755-1765

Thisⁱ chair has "eagle claw" feet (Figure 26; Plate XVI) like those Elfe mentioned in his Account Book. Now in the Humphrey Sommers parlor at MESDA with the Queen Anne chair also described in this book, it is a favorite of visitors.

As MESDA described the frame, it has:

...a low arching crest, a very vertical, two-part wing lapped and nailed to the rectangular back frame and dovetailed and nailed to the ash seat frame. The projecting, outsweeping arms are supported by cone shaped members which are lapped and nailed onto the seat frame. There are somewhat smaller terminations on the rear legs.

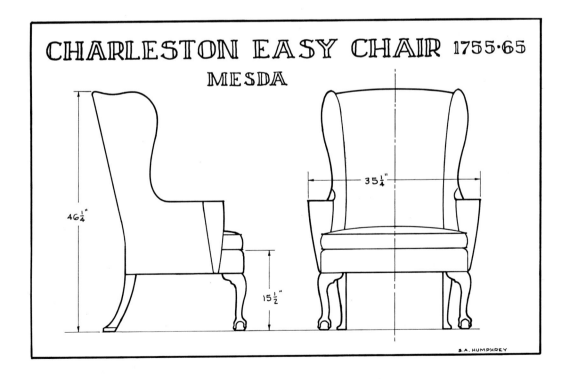

CHARLESTON EASY CHAIR 1755·65
MESDA

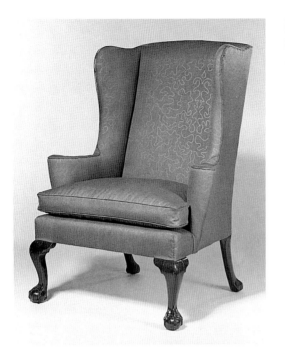

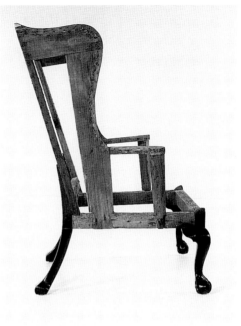

Mahogany primary, ash seat frame, tulip poplar back posts, arm supports, and two glue blocks; the remainder of the frame and two other glue blocks are of cypress.

Rear leg terminations make a difference. Stump rear legs on many Virginia to New England easy chairs fail to balance the visual weight of their carved front legs. According to MESDA, large rear feet are a Charleston characteristic (Figure 27). They are also found on some New York furniture from this period.

Library Bookcase

This Charleston library bookcase (Plate XVII) is another example of a Thomas Chippendale design (Figure 28), appearing in all three editions of the *Director*. If Elfe made it — a surmise based on the fret and key — that would date it somewhere between 1754 (first edition of the *Director*) and Elfe's death in 1775. The mahogany with cypress secondary wood construction (1) localizes it to Charleston. Elfe's account book listed a sale of a similar bookcase in 1772 to John Dart. Elfe and Hutchinson also made one in 1759 for the colonial secretary's office. That one might have been destroyed in the 1788 State House fire.

The original owner of this chest is not known; however, the earliest known owners were the Willis family of Tradd Street in Charleston during the Civil War. It

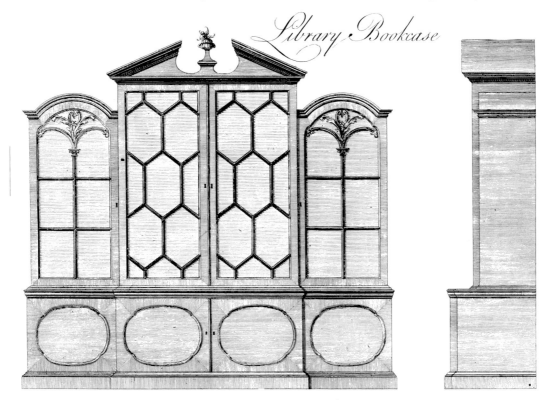

Library Bookcase

Figure 28

57

LIBRARY BOOKCASE (MESDA)

SECTION A·A

DOORS REMOVED

$\frac{3}{32}$" INLAY

HINGE

MEASURED & DRAWN BY S.A.HUMPHREY

FIGURE 29

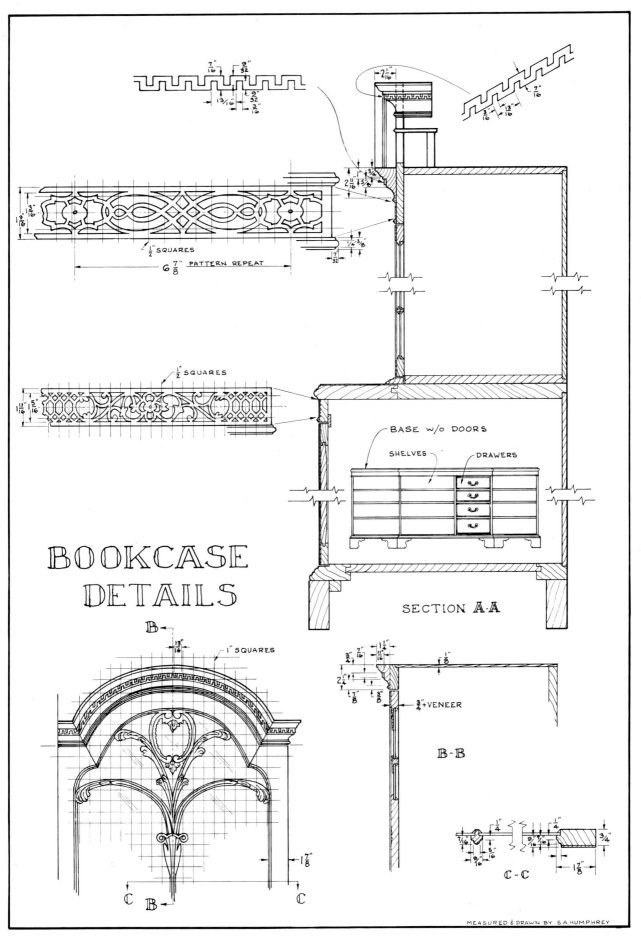

BOOKCASE DETAILS

½" SQUARES

6 7/8" PATTERN REPEAT

½" SQUARES

BASE w/o DOORS

SHELVES

DRAWERS

SECTION A-A

1" SQUARES

B-B

3/4" + VENEER

C-C

FIGURE 30

may have been shipped North as a war prize after the capture of Charleston. It next appeared in Massachusetts with its feet and pediment removed to permit its use in a low ceilinged room.

It was purchased before 1952 by the New York City antiques firm, Ginsburg and Levy. Next it was purchased by Frank Horton who took it to Winston-Salem, North Carolina where it remains today, fully restored, at MESDA, which he founded.

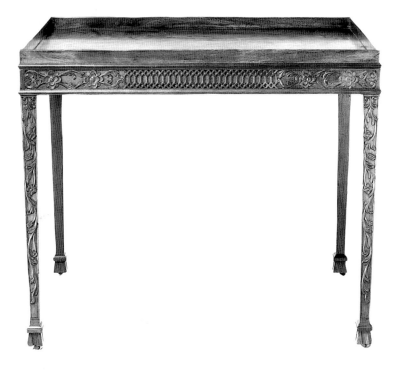

Figure 31

Design and construction of a major cabinet piece such as this demands some coordination with available wall space and ceiling height. Chippendale's design was 8′ 9 1/2″ high by 9′ 6″ wide, but this piece was actually built 8′ 11″ high x 7′ 8″ wide, changing it from a predominantly horizontal to a vertical composition. Note the way the veneered panels in the lower doors (Figure 29) are rotated ninety degrees from the original design. MESDA included this piece in their Humphrey Sommers reproduction parlor, making the room two feet longer than the original to accommodate it.

Other cabinetmakers also liked the original Chippendale design and used it. There is a similar bookcase in the White House collection. Made in 1810 in Baltimore, it has some Federal embellishments, but is obviously the same basic Chippendale design.

The upper fret on this Charleston bookcase (Figure 30) is a perfect replica of those on Mr. Dwight's chest and the others. These applied frets are all 1 3⁄16" wide with a repeat of 6 7⁄8". The fret on the lower section, however, has a different pattern and was incised out of the solid mahogany. Design of that fret nearly matches applied frets on two "China tables" from the Hay shop in Williamsburg, Virginia. One of these tables, c. 1765, is believed to have been owned by George Washington at Mt. Vernon. It is now in Washington, DC at the National Museum of American History (Figure 31). The second table, built 10 years later, is in a private collection.

The use of these similar frets raises questions of attribution about all of these pieces. When asked about the similarity, Wallace Gusler, Director of Conservation at Colonial Williamsburg, said, "The hexagonal fret...probably represents 'generic' English influence, accidental via transmission of British style to both schools," but he still felt it deserved further examination. He noted that there had been other hints of a connection between Williamsburg and Charleston.

How the Williamsburg fret then found its way onto the library/bookcase along with the Charleston fret remains a mystery.

Bed at Shirley Plantation

There is a reputed Charleston bed at Shirley, an eighteenth century plantation on the James River between Williamsburg and Richmond, Virginia — a long way from Charleston. This mansion with its twin two-story porches and spectacular inside staircase is one of the most beautiful in Virginia. Shirley Plantation was granted to Edward Hill in 1660.

The present building was constructed in 1723 by a descendant, also named Edward Hill, for his daughter Elizabeth. She married John Carter, son of Robert "King" Carter, the richest man in Virginia [Robert Carter gave his daughter Elizabeth (John's sister) seven thousand nearby acres on which her son (Carter Burwell) built the Carter's Grove mansion.]. The Shirley estate has remained in the Hill and Carter families to this day.

One of their descendants, Anne Hill Carter, was married in the living room of Shirley. Later, her son Robert E. Lee led the Confederate Army in The War Between The States.

Louise Humphreys married Robert Randolph, a Carter cousin, and spent much of the Civil War at Shirley. She was the daughter of Union General George Humphreys of Massachusetts. Because of her presence at Shirley and because of her and the other Shirley women's many kindnesses to wounded Union soldiers, Shirley survived the war. The ninth generation present owner of Shirley is Mr. Hill Carter.

The bed (Plate XVIII) had been purchased after World War II from a Richmond antique dealer, now deceased, who had sold it to Mr. Carter with the Elfe attribution and a history of it having once been in the coastal city of Norfolk, Virginia.

With Marlboro feet and rice carving on the mahogany front posts (Plate XIX), they may very well be of Charleston origin and may even have been sold by Elfe, although there were no labels or other documentation to tie the piece to Thomas Elfe or anyone else. Elfe, it appears, was not a carver, and would probably have hired one if he had been responsible for the piece. Though not identical, the bed shows a lot of similarity to other Charleston rice beds illustrated in Milby Burton's book.

The headboard and rear posts do not match the foot posts — not surprising, since many Charleston front bed posts were sold and carried up-country where the rest of the bed was made locally of pine or other available materials. These front bed posts could have been carried by ship from Charleston to Norfolk.

THE ELFE BED AT SHIRLEY

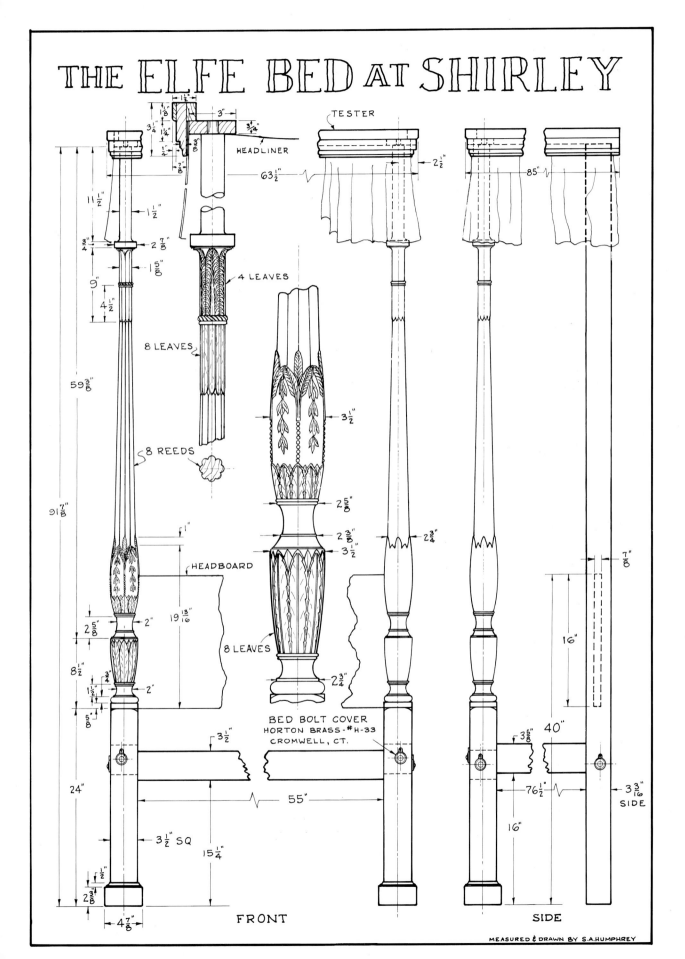

TESTER

HEADLINER

4 LEAVES

8 LEAVES

8 REEDS

HEADBOARD

8 LEAVES

BED BOLT COVER
HORTON BRASS - #H-33
CROMWELL, CT.

FRONT

SIDE

SIDE

MEASURED & DRAWN BY S.A.HUMPHREY

Marble Slab Table

Thomas Elfe listed more than 20 sales of Slab Tables in his Account book. Some of them had marble tops. There are no clues to link this table (Plate XX) to Elfe, other than that it was made in Charleston during his lifetime. He could have built the table or merely sold it.

Although native marble was later shipped into Charleston from Philadelphia, 18th century Charleston marble most likely came from Europe. The finest white marble was, and still is, from Carrara, Italy. This table top has the characteristic warm translucence of fine white Carrara marble caused by light reflected from about 1⁄2 inch below the surface.

With shells and drop husks carved on the front legs and half-carved on the rear legs, this mahogany table has cypress secondary woods, the Charleston fingerprint. The rear apron is also cypress. This top weighs about 100 pounds, about five times as heavy as mahogany, and so the inner construction is appropriately robust.

MESDA believes that this table was made about 1740-1750, and they have traced it back to James Henry Ladson who lived at 8 Meeting Street in Charleston. It is now in the Humphrey Sommers Parlor at MESDA.

CHARLESTON MARBLE SLAB TABLE
1740-50 (MESDA)

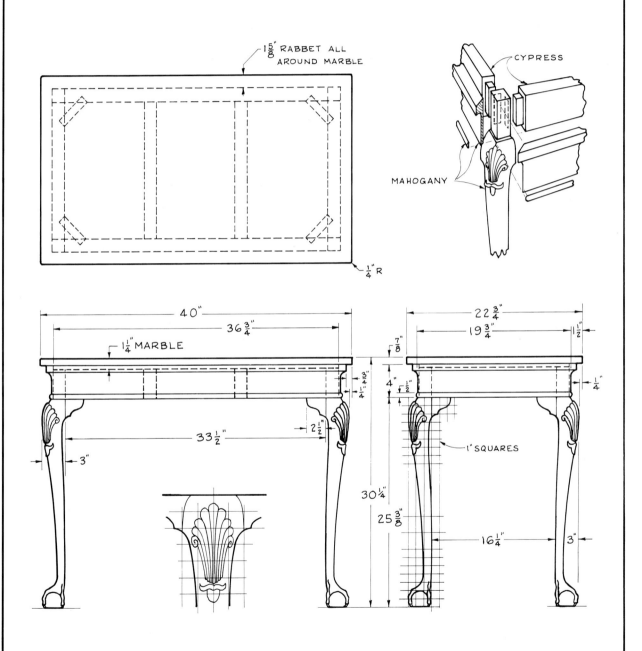

1 5/8" RABBET ALL AROUND MARBLE

1/4" R

CYPRESS

MAHOGANY

40"

36 3/4"

1 1/4" MARBLE

33 1/2"

2 1/2"

3"

22 3/4"

19 3/4"

1 1/2"

7/8"

4"

1 1/2"

1/4"

1" SQUARES

3 1/2"
1 1/4"

30 1/4"

25 3/8"

16 1/4"

3"

The "Mystery" Chest

For a double chest with fret and pediment like this, Elfe charged an extra £10. Only four of the 28 double chests in his Account Book had pediment heads.

For some years, location of this chest (Figure 32) was a mystery. Milby Burton, in his 1952 book on Elfe, credited Joe Kindig, Jr. of York, Pennsylvania, with permitting "use of the line drawing of the double chest of drawers now in his possession." (Figure 33.) In the 1955 book, he used the same drawing again and acknowledged several dealers who had supplied him with illustrations of Charleston-made pieces. Among them were Joe Kindig, Jr. and Joe Kindig III. A photo of the chest appeared anonymously in a 1952 *Antiques* Magazine book.

Like many another cabinetmaker whose eye is caught by a striking piece of furniture, Daniel Hinson, a present day Charleston cabinetmaker, was fascinated with the photo and drawings and the challenge they represented. From those limited bits of information he built a reproduction of the chest. It is now in the collection of the professional ship model builder, Mr. P.C. Coker III of Charleston.

In Mr. Hinson's shop, I found the full size layout he had made of the pediment on a 2 ft. x 4 ft. piece of plywood. He loaned it to me so that I could make the accompanying drawing. Of interest is the fact that his copy of the fret had the same width and repeat length as the fret on the others. Mr. Hinson had scaled his fret from the photo and sketches of this chest.

The rest of the chest is remarkably similar, though not identical, in dimensions and construction to Mr. Dwight's chest, shown elsewhere in this book. Actually, none of the similar pieces measured for this book exactly matched, but differences of fractions of an inch could be observed throughout. One significant but tiny difference on this chest from Mr. Dwight's chest is the addition of five small "U-dots" capping the columnar flutes on each chamfered corner of the upper half.

I found the Mystery Chest at Williamsburg (It was not really lost after all). Joe Kindig III had sold it to Colonial Williamsburg in 1974 and it is now displayed there in the DeWitt Wallace Decorative Arts Gallery.

Next to it stands another fine double chest with fret and pediment. Attributed to Thomas Affleck, one of the outstanding colonial Philadelphia cabinetmakers, it suffers from comparison with the quiet elegance and masterful execution of the Charleston piece.

When Wallace B. Gusler of Colonial Williamsburg asked Milby Burton for information on the chest, Burton referred him to Alston Deas of Mt. Pleasant, South Carolina, who supplied the following in his letter of October 12, 1975:

"It belonged to my great, great, great grandfather, John Deas, of Charleston. Later on, it was owned by his grandson, Dr. Elias Horry Deas, then to the latter's daughter, Miss Anne Simons Deas, and then to me. I sold it to Harry Arons. I understand that he refitted the desk drawer; there were no fittings when I owned it. I also understand that he sold it to Mr. Kindig."

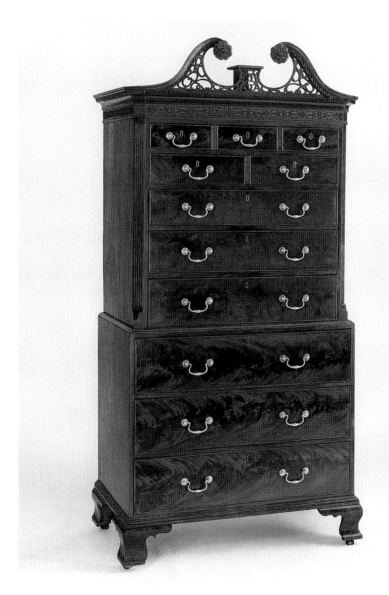

Figure 32

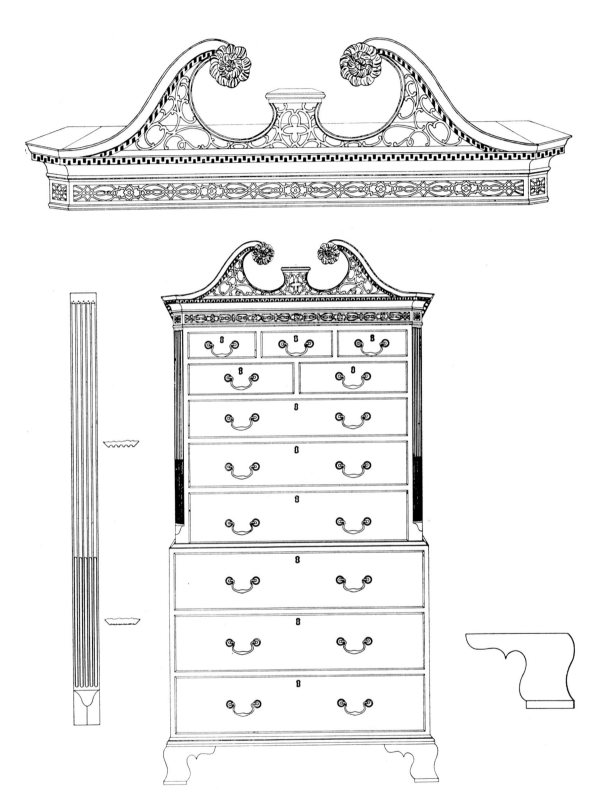

Figure 33

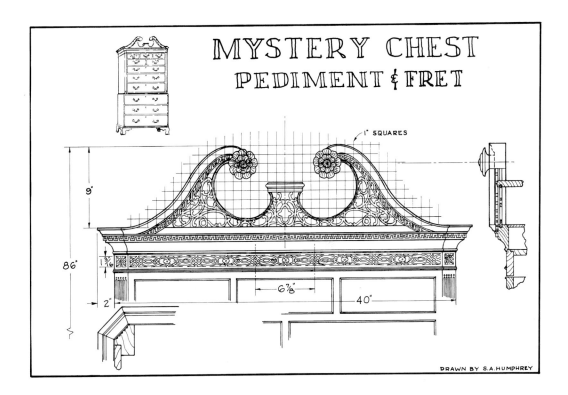

MYSTERY CHEST
PEDIMENT & FRET

DRAWN BY S.A.HUMPHREY

In 1788 Humphrey Sommers died, leaving his Tradd Street home to his daughter Mary, who later married Mr. David Deas. Could members of the Deas family once have owned both this pedimented chest in the Williamsburg museum and the original chest purchased by Humphrey Sommers in 1772 and listed in Elfe's Account Book?

The Williamsburg chest has similar but slightly larger brass handles than Mr. Dwight's. Although all of the other chests in this body of furniture have had drawers which are graduated in height from bottom to top, the three drawers in the bottom section of this chest are all nine inches deep. The top drawer of the bottom section has had its desk section entirely removed, while the lower two drawers have the same muntin bottom supports found in several of the other chests.

Dimensions of the antique:
Overall height: 87" (includes casters)

	Cornice	Upper Case	Lower Case	Feet
Width	44 3/16"	40"	42"	44 1/2"
Depth		21 7/8"	22 15/16"	24 3/8"

Miles Brewton's Armchair

Once there were twelve of these chairs in the home of Miles Brewton at 27 King Street in Charleston. Two of them arrived in Robert Saarco's cabinetmaking shop for repairs at the same time this book was being prepared. That provided the rare opportunity, with the current owner's permission, to share with you the internal construction (Plate XXI).

The chairs show evidence of previous repairs and many re-upholsterings. They quite likely came from the shop of Thomas Elfe, even though the presence of beech and birch secondary woods was at one time thought to be an English identifier; however, the U.S. Forest Products Laboratory has stated that these woods were widely available in both the Colonies and England and cannot be identified as to origin.

Miles Brewton, a wealthy member of the Colonial Assembly, completed his home, now recognized as one of the finest Georgian town houses in this country, in 1769. It recently underwent a thorough renovation at the same time as did some of the furniture. Some interior trim, as well as the exterior Ionic entablature, was the work of Ezra Waite, a master builder from London. Among Ezra Waite's effects when he died in 1769 was a copy of Chippendale's *Director*.

Miles Brewton and his immediate family perished at sea in 1775, the same year Elfe died. Brewton's property was inherited by his sisters, and the house has remained in the family ever since. Mottes, Alstons, Pringles and Manigaults, have all owned the house.

Originally the set of twelve chairs was used in the banqueting hall high above King Street. These chairs were used by the family and by the British commander, Sir Henry Clinton, who chose the house as his Revolutionary War headquarters, and by Union Generals Hatch and Meade, who also made it their headquarters during the Civil War.

Most of the chairs have disappeared, distributed through inheritances, etc. Photos of the survivors have appeared in books and magazine articles in this century.

MILES BREWTON'S ARMCHAIRS

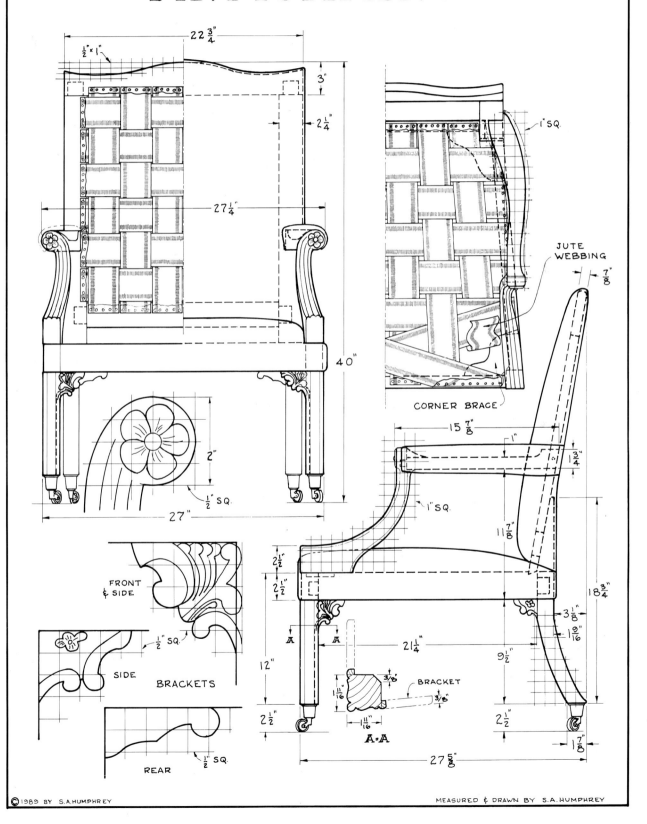

22 3/4"

1/2" x 1"

3"

2 1/4"

27 1/4"

40"

2"

1/2" SQ.

27"

1" SQ.

JUTE WEBBING

7/8"

CORNER BRACE

15 7/8"

1"

3/4"

1" SQ.

11 7/8"

18 3/4"

2 1/2"

2 1/2"

3 1/8"

9/16"

FRONT & SIDE

1/2" SQ.

SIDE

BRACKETS

A

A

21 1/4"

12"

BRACKET

3/8"

3/8"

1 11/16"

9 1/2"

2 1/2"

2 1/2"

1 11/16"

A·A

REAR

1/2" SQ.

7/8"

27 5/8"

MEASURED & DRAWN BY S.A. HUMPHREY

The Field Bed in the South Carolina Governor's Mansion

In one of the guest wing bedrooms of the Governor's Mansion in Columbia, South Carolina, stands the field bed (Figure 34) said to have belonged to Arthur Middleton. With modest hangings, matching quilt, and a modern box spring/mattress, this old bed still offers the Governor's guests a pleasant night's rest.

Arthur Middleton was born in 1742 at Middleton Place, a plantation on the Ashley River just above Charleston. Educated in South Carolina and in England, he returned to South Carolina in 1763 and was elected to the colonial legislature in 1765. He married Mary Izard in 1768, and they went back to Europe on an extended honeymoon until 1771.

In December 1771, Elfe purchased 200 feet of dry cypress from Arthur Middleton. Although there is no record in the Account Book of a bed sale to Middleton, it could have occurred between 1763-1768 or 1771-1775. If Middleton bought it before May, it would not have appeared in the Account Book, because prior to that time almost all of Elfe's sales would have appeared in other account books which are now lost. So the bed was either bought during early 1771 or the earlier period, if it was indeed sold to Middleton by Elfe. On June 20, 1768, in the South Carolina *Gazette*, Elfe offered his home, "at the top of Broad-Street, opposite to Arthur Middleton, Esq." for rent. This must have referred to Middleton's town house. They were not only acquainted, they were neighbors.

Middleton went to Philadelphia in 1776 as a delegate to the Continental Congress and there signed the Declaration of Independence. He was there until October, 1777, when he returned to help defend Charleston.

Whether the bed actually went along on any of Middleton's travels is not known. It next appeared in the possession of Arthur's great, great, grand niece, Miss Alicia Hopton Middleton, who lived in Bristol, Rhode Island. Nathaniel Russell, whose father had been Chief Justice of Rhode Island, came to Charleston from Bristol and became a very successful merchant. His house is today a museum on Meeting Street. Russell's daughter Alicia married Arthur Middleton of Bolton Plantation on the Stono River, nephew of Arthur of Middleton Place.

The bed may have been purchased by nephew Arthur of Bolton; nevertheless,

it stayed in the family, finding its way to Bristol. In 1937, this second Alicia Middleton sold the bed to Joe Kindig II, the York, Pennsylvania antique dealer.

Kindig sold the bed to Mrs. Harry Beling Dupont, then re-acquired it in 1960. Next, he sold the Middleton bed to Mrs. W.A. Clarke of Wallingford, Pennsylvania. Milby Burton learned of the bed's existence through the Kindigs, and passed the information to Mrs. Robert McNair, wife of the South Carolina Governor. Several South Carolina businessmen purchased the bed for the mansion in 1967.

The bed today bears many scars from its travels over the last two hundred years. The head board is removable and it has been replaced, as have the side and

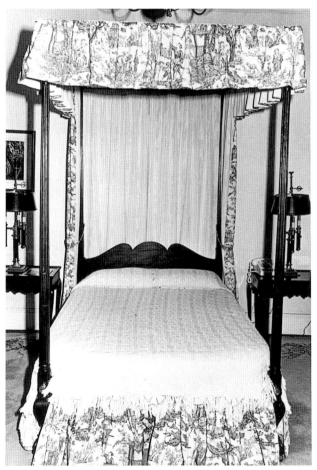

Figure 34

end rails. The tops of all four posts have been lengthened about 4 inches, to restore them to their original length. The casters appear to be replacements. Very likely the tester is also a replacement, as the original was probably discarded when the tops of the posts were removed, perhaps to accommodate a lower ceiling.

All four posts separate about 3 feet above the floor, leading to the designation of "field bed." The Mansion's "Accession and Condition Report" states that these posts were "later doweled and glued back together." The glue may have been added to tighten up the loose, worn joints at the time the tester was discarded. The bed may either have been originally made to be disassembled or have been cut, drilled and doweled at a later date.

In 1987, the staff at the Governor's Mansion asked another museum's opinion of the Elfe attribution. The initial evaluation, based on a photograph, was that the bed was from New York. The character of the ball and claw feet and the cabriole legs favored New York. This evaluation seemed to ruin any possible Elfe or even South Carolina attribution; however, that museum now agrees the bed is from Charleston. Brad Rauschenberg of MESDA agrees.

[There is little difference between many Charleston and New York ball and claw feet and cabriole legs. This was the result of common training in either England or this country. New York trained carvers carried their carving habits south with them, lured by the money to be made in Charleston. Records show that Elfe employed many of them.]

One feature of the bed is especially noteworthy. At the tops of the foot post flutes the terminations are inverted, resembling U's or half-circles with a small incised hole just above each flute. While this unusual "U-dot" device may occasionally be seen between applied cornice dentils of some English furniture, "U-dotted" flutes seem to have been a Charleston, and perhaps even an Elfe, identifier. The "U-dot" was used on letter drawers of desk interiors and on several of the double chests with a small "dot," and on bed posts, using a larger "dot." Most importantly, it was used on the four poster bed in the Heyward-Washington House. Another application of "U-dots" may be seen in that same house between the Greek keys of the drawing room mantel, which also has the Charleston, or Elfe, fret.

[*Cabinetmaker note*: Modification of the end and side rails to permit use of a modern mattress and box springs set may be of interest to anyone wishing to convert or reproduce one of these old beds for comfortable, contemporary use. Standard, modern mattress and box spring units are made in 48" (3⁄4), 54" (full) and 60" (queen) widths. This permits pairing a 6" narrower box spring to a full or queen size mattress which just covers the side rails. Mattress thickness varies and must be taken into account in the selection and mounting of the metal support brackets.]

THE FIELD BED IN THE
S.C. GOVERNOR'S MANSION

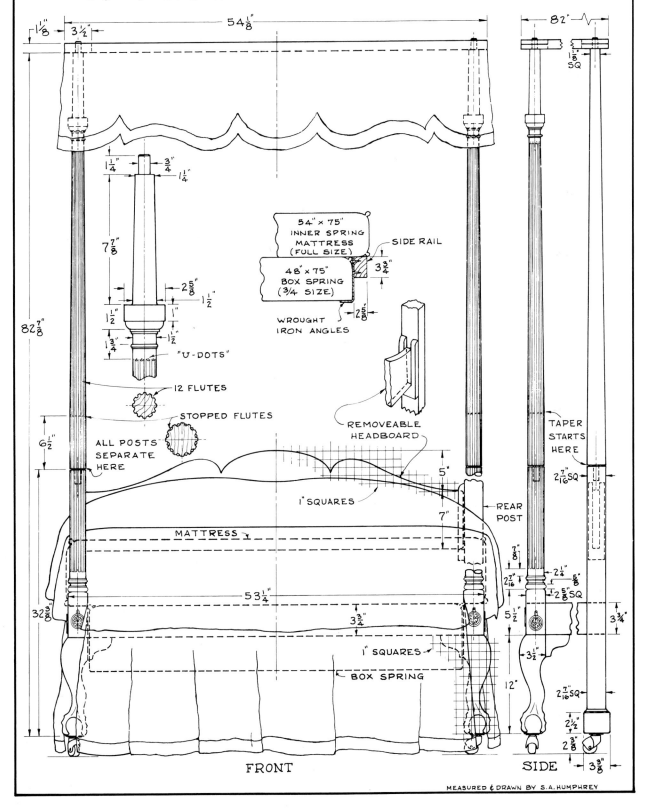

54⅛"
82"
1⅛"
3½"
1⅛" SQ

1¼"
¾"
1¼"

7⅞"

54" × 75"
INNER SPRING
MATTRESS
(FULL SIZE)

SIDE RAIL

2⅝"
1½"
1½"

48" × 75"
BOX SPRING
(¾ SIZE)

3¾"

1½"
1¾"

"U-DOTS"

2⅝"

WROUGHT
IRON ANGLES

82⅞"

12 FLUTES

STOPPED FLUTES

REMOVEABLE
HEADBOARD

5"

6½"

1" SQUARES

7"

ALL POSTS
SEPARATE
HERE

TAPER
STARTS
HERE

2 7/16 SQ

REAR
POST

MATTRESS

7/8"

2 7/16"

2¼"
⅝"

53¼"

2⅝" SQ

32⅜"

3¾"

5½"

3¾"

1" SQUARES

3½"

BOX SPRING

12"

2 7/16 SQ

2½"
¼"

2⅜"

FRONT

SIDE

3⅜"

MEASURED & DRAWN BY S.A. HUMPHREY

COLOR PLATES

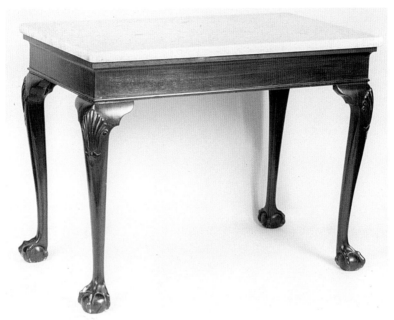

PLATE XX

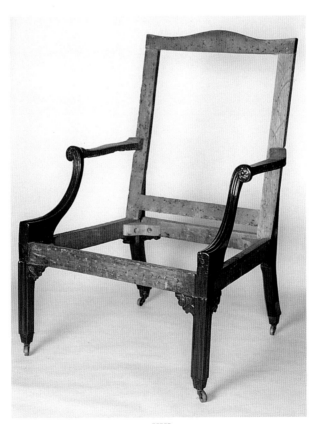

PLATE XXI

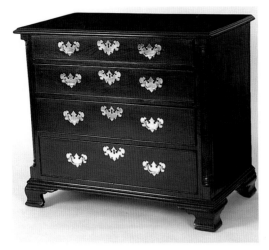

PLATE *XXII*

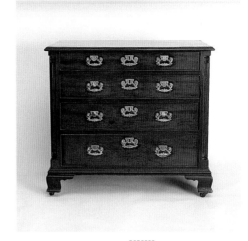

PLATE *XXIII*

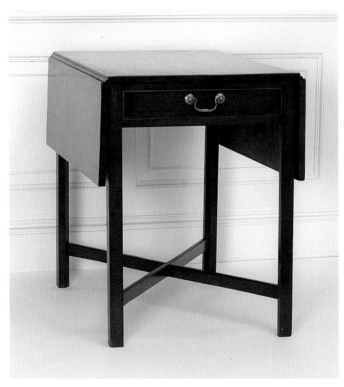

PLATE *XXIV*

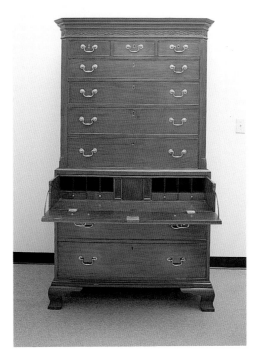

PLATE *XXV*

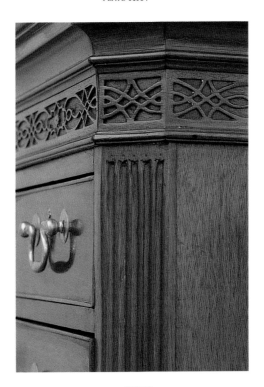

PLATE *XXVI*

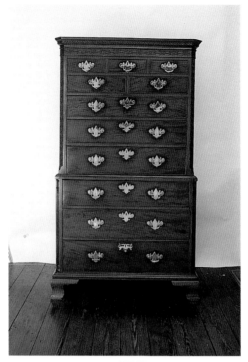

PLATE *XXVII*

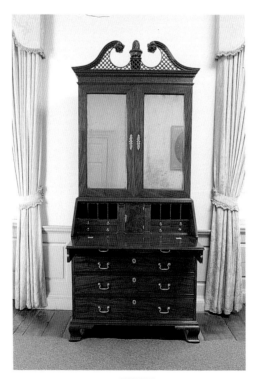

PLATE *XXVIII*

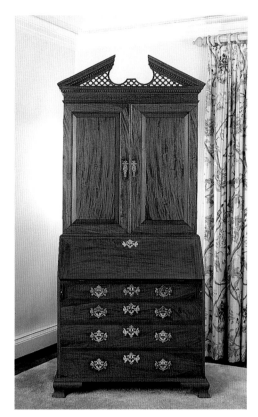

PLATE XXIX

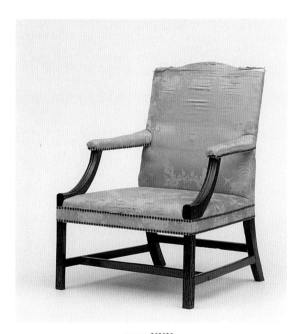

PLATE XXX

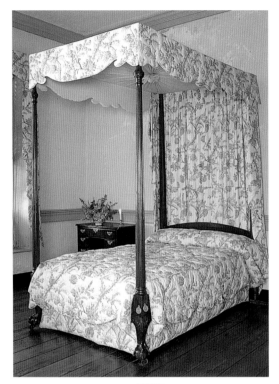

PLATE XXXI

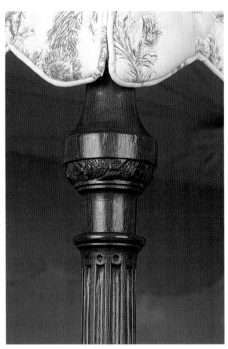

PLATE XXXII

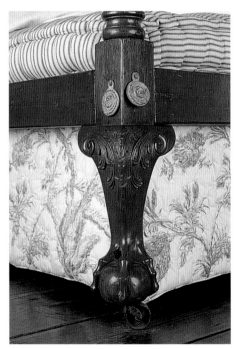

PLATE XXXIII

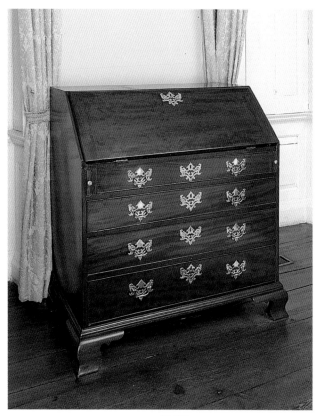

PLATE *XXXIV*

PLATE *XXXV*

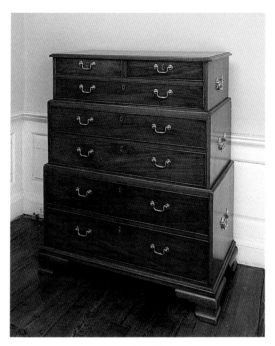

PLATE *XXXVI*

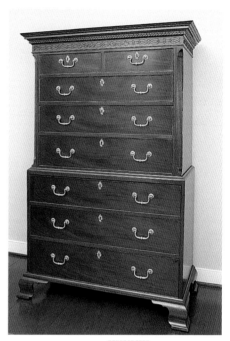

PLATE *XXXVIII*

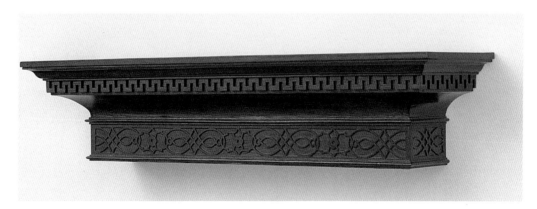

PLATE *XXXVII*

Two Charleston Dressing Drawers

These two nearly identical half-chests probably came from the same Charleston shop. Today, one is at MESDA in Winston-Salem, North Carolina (Plate XXII) with a history of ownership in the Cannon-Frazer families of Charleston. Located in one of the Humphrey Sommers reproduction rooms where the furnishings more or less match the Account Book list of similar items purchased from Elfe by Sommers in 1772-73, it matches the "Ladies dressing drawers for daughter."

The second chest (Plate XXIII) stands in Nathaniel Russell's second floor bedroom on Meeting Street in Charleston. Little is known of its history, although it was owned by Dr. Kinloch's family who lived on Church Street in this century. The chest later had wandered as far as Marion, Pennsylvania, when the Historic Charleston Foundation acquired it from the Kinloch family.

The two chests are of mahogany with cypress secondary wood identifying them as Charleston-made. Both have the same ogee feet and base molding used on other chests described herein. Cockbeading on the drawers is the same, but there are no muntin braces in the drawer bottoms. Instead, the grain in the drawer bottoms runs fore and aft. Beveled into grooves at the front and sides, the drawer bottoms pass under the backs to which they are nailed. Like other Charleston chests, the dust stops extend only about three-fourths of the way to the rear. As in Mr. Dwight's double chest, the drawer stops consist of thin mahogany blocks, nailed and glued to the drawer dividers where they can catch the inside faces of the drawer fronts.

Many Charleston half chests, like these, have no dividing strip between the upper drawer front and the top of the chest. Brasses on the MESDA chest have been replaced. Those on the Russell House chest match those on some other antiques in Charleston. The top drawers of both chests are divided into small compartments for holding dressing items.

CHARLESTON
HALF·CHEST · MESDA

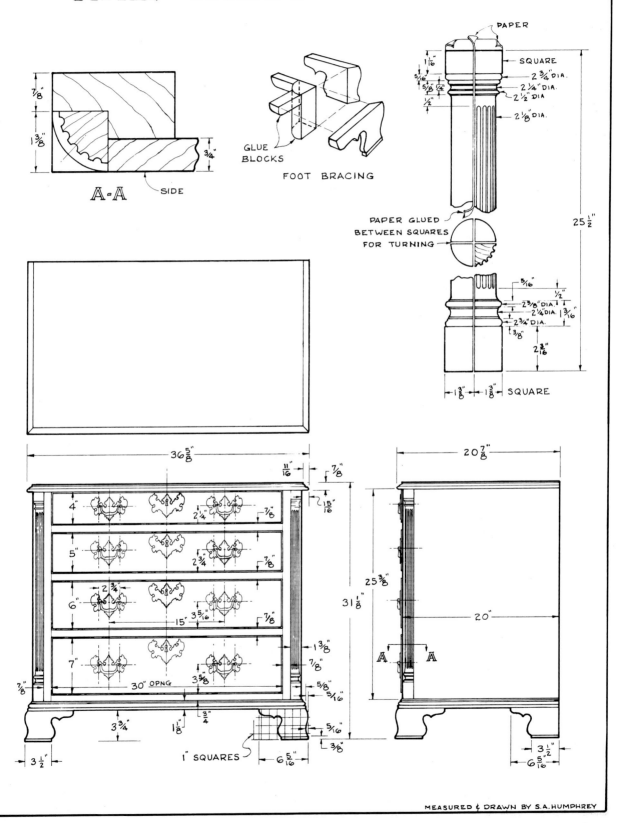

A-A

SIDE

7/8

1 3/8"

3/4

GLUE BLOCKS

FOOT BRACING

PAPER

SQUARE

2 3/4" DIA.

2 1/4" DIA.

2 1/2" DIA.

2 1/8" DIA.

1 1/16

5/16

5/8 1/4

1/2

25 1/2"

PAPER GLUED BETWEEN SQUARES FOR TURNING

5/16

1/2"

2 3/8" DIA.

2 1/4" DIA. 1 3/16"

2 3/4" DIA.

3/8"

2 3/16"

1 3/8" 1 3/8" SQUARE

36 5/8"

11/16

7/8

1 5/16

4

2 1/4

7/8

5

2 3/4

7/8

6

2 3/4

15" 3 5/16

7/8

7

3 5/8

31 1/8"

1 3/8"

7/8

30" OPNG.

7/8"

3 3/4"

1 1/8"

3/4

5/8"

5/16"

3/8

1" SQUARES

3 1/2

6 5/16"

20 7/8"

25 3/8"

20"

A A

3/8

3 1/2"

6 5/16"

MEASURED & DRAWN BY S.A. HUMPHREY

DRESSING DRAWERS
NATHANIEL RUSSELL HOUSE

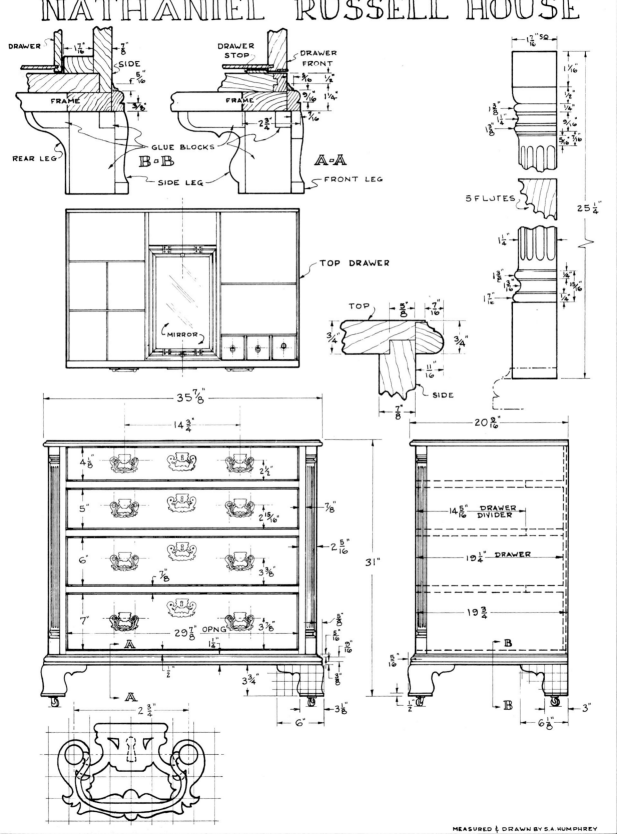

DRAWER

SIDE

FRAME

REAR LEG

GLUE BLOCKS

B-B

SIDE LEG

DRAWER STOP

DRAWER FRONT

FRAME

A-A

FRONT LEG

$1\frac{7}{16}$" $\frac{7}{8}$"

$\frac{5}{16}$"

$\frac{3}{8}$"

$2\frac{3}{4}$

$\frac{5}{16}$ $\frac{1}{2}$

$\frac{9}{16}$" $1\frac{1}{4}$"

$\frac{7}{16}$"

$1\frac{7}{16}$" SQ

$1\frac{1}{16}$

$\frac{1}{2}$ $1\frac{1}{4}$

$\frac{9}{16}$

$\frac{5}{16}$ $\frac{7}{16}$

$1\frac{3}{8}$" $1\frac{1}{4}$

$1\frac{3}{8}$"

$25\frac{1}{4}$"

5 FLUTES

$1\frac{1}{4}$"

$1\frac{3}{8}$" $1\frac{3}{16}$"

$1\frac{7}{16}$"

$\frac{1}{4}$ $\frac{1}{2}$

$\frac{1}{4}$ $15\frac{1}{16}$"

TOP DRAWER

MIRROR

TOP

SIDE

$\frac{5}{8}$" $\frac{7}{16}$"

$\frac{3}{4}$" $\frac{3}{4}$"

$\frac{11}{16}$"

$\frac{7}{8}$"

$20\frac{9}{16}$"

$35\frac{7}{8}$"

$14\frac{3}{4}$"

$4\frac{1}{8}$ $2\frac{1}{2}$

5" $2\frac{15}{16}$" $\frac{7}{8}$

6" $2\frac{5}{16}$"

$\frac{7}{8}$" $3\frac{3}{8}$"

7" $29\frac{7}{8}$" OPNG $3\frac{7}{8}$" 31"

A

A

$2\frac{3}{4}$"

$1\frac{1}{4}$"

$\frac{1}{2}$

$3\frac{3}{4}$

$3\frac{1}{8}$"

6"

$14\frac{5}{16}$" DRAWER DIVIDER

$19\frac{1}{4}$" DRAWER

$19\frac{3}{4}$

B

B

$\frac{5}{16}$

$\frac{1}{2}$

$6\frac{1}{8}$" 3"

MEASURED & DRAWN BY S.A. HUMPHREY

The Pembroke Table
at Harrietta Plantation

Lord Pembroke's purchase of a small, drop-leaf table from Thomas Chippendale is believed to have given this form the name it has carried ever since. Pembroke tables became part of the repertoire of most late eighteenth century cabinetmakers. Probably since these tables were more common at that later time, this one (Plate XXIV) was attributed to Thomas Elfe, Jr. by the Savannah, Georgia, dealer who supplied it to its present owner. That owner does not feel sure of the table's history, since there is little on which to base such an attribution.

Very little furniture was made in Savannah until after the British left in 1782, the town having become little more than a military outpost. Nevertheless, the table does appear to be Southern and could have been made by Elfe, Jr. during the time he was a cabinetmaker in Savannah after the Revolution. He evidently went there to avoid the harsh treatment his family received in Charleston for their Tory sympathies.

The boy was only 16 and still an apprentice when his father died in 1775. He did not have the training and experience of a master. While the table is a standard design, it lacks the sophistication and gracefulness of his father's work. Nor would it have brought the price.

Three years later, at age 19, Elfe, Jr. was married to Mary Padgett. Only two years later, in 1780, the British took Charleston and, responding to the threats of heavy British penalties against the citizenry, he made the bad mistake of petitioning Sir Henry Clinton to be returned to the status of a British citizen. When the British left at the War's end in 1783 he was in trouble and lost some of his property. By 1784, at age 26, he was in Savannah. Later he returned to Charleston, working as a carpenter.

The table has been restored, including a new piece set into the wide single-piece top to correct shrinkage and a possible split. This type of repair is common since these table were frequently made with the folded leaves resting almost directly against the legs. This left no room for shrinkage, so the table top either split or forced the leaves to hang at an awkward angle out from the sides. [*Cabinetmaker note*: To avoid this in a reproduction, the top should be made about 1/8" wider and be secured to the skirts through slotted holes.]

PEMBROKE TABLE

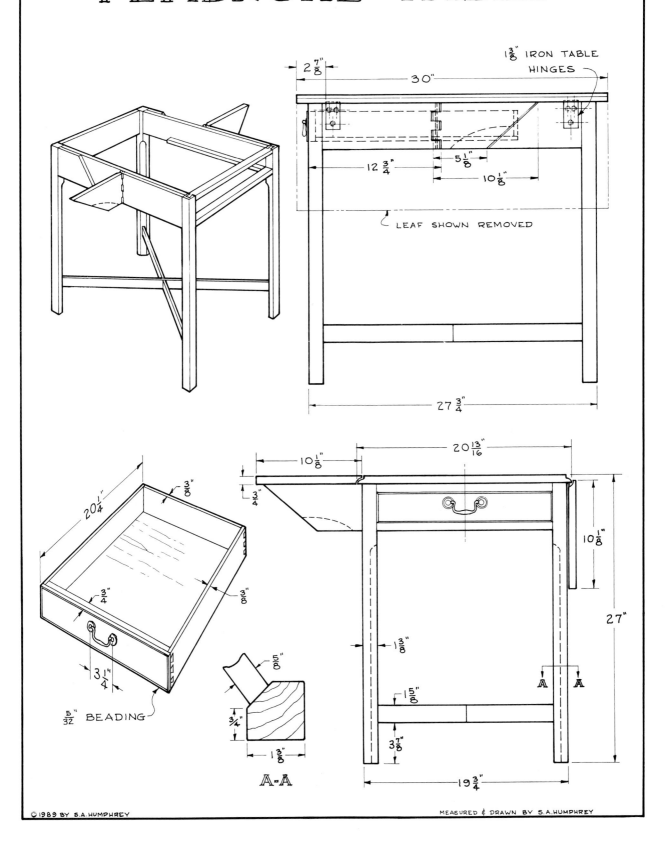

$2\frac{7}{8}"$

$30"$

$1\frac{3}{8}"$ IRON TABLE HINGES

$12\frac{3}{4}"$

$5\frac{1}{8}"$

$10\frac{1}{8}"$

LEAF SHOWN REMOVED

$27\frac{3}{4}"$

$20\frac{1}{4}"$

$\frac{3}{8}"$

$\frac{3}{4}"$

$\frac{3}{8}"$

$3\frac{1}{4}"$

$\frac{5}{32}"$ BEADING

$\frac{1}{8}"$

$\frac{3}{4}"$

$1\frac{3}{8}"$

A-A

$10\frac{1}{8}"$

$20\frac{13}{16}"$

$\frac{3}{4}"$

$10\frac{1}{8}"$

$1\frac{3}{8}"$

$1\frac{5}{8}"$

$3\frac{7}{8}"$

$19\frac{3}{4}"$

$27"$

A A

MEASURED & DRAWN BY S.A.HUMPHREY

The Sinkler Family's Double Chest

With all its lights ablaze, the George Eveleigh house at evening is one of Charleston's delights, both inside and out. Wide cypress paneling, large windows with much original glass intact, and turned stair balusters almost identical to those made by Elfe and Hutchinson for St. Michael's Church, enrich this house.

The house once stood on the bank of Vanderhorst Creek, long since filled in to become lower Church Street, but the once-waterside mooring stanchions are still there marking the bend in the former creek. Built in about 1743 by a fur trader, George Eveleigh, the house passed through several families until it came into the hands of the Marshall family in 1875.

Most of the furniture and artifacts in this home were selected and arranged by Mrs. Alida Canfield Sinkler, wife of Huger Sinkler. Both are now deceased.

There is a double chest (Plate XXV) which, until recently, stood in the drawing room on the upper floor. Similar to other Charleston double chests, this one has "frett round" and it also features a desk in the upper drawer of the lower chest. In his Master's thesis, John C. Kolbe postulated that these Charleston chests with a desk drawer were a harbinger of the Neoclassical furniture which appeared in the northern colonies in the 1780s and 1790s, actually about 10 to 20 years behind the London styles. Elfe, on the other hand, was more nearly current with the London styles and reflected the highly urban and sophisticated nature of Charleston.

Alida Sinkler and Mrs. Robert S. Cathcart, partners in an antiques business, discovered the double chest at Wampee Plantation near Eutawville, South Carolina. The two halves had been separated and were being used in different buildings. (This was not an uncommon practice.)

The partners bought the chest from the Stroman family who had lived at Wampee since buying the plantation from William Sinkler after the Civil War. Wampee had been in the Sinkler family for several generations before the war and it is assumed that William's great-grandfather, Captain James Sinkler (1740-1800) purchased the chest from Elfe.

Two lower drawers of the bottom chest have the muntin braces typical of Elfe's large pieces, but the drawers of the upper unit do not. There is no Greek key in the cornice and it does not lift off. Brasses are similar to those on Mr. Dwight's chest. Flutes of the corner pilasters terminate in "U-dots" (Plate XXVI).

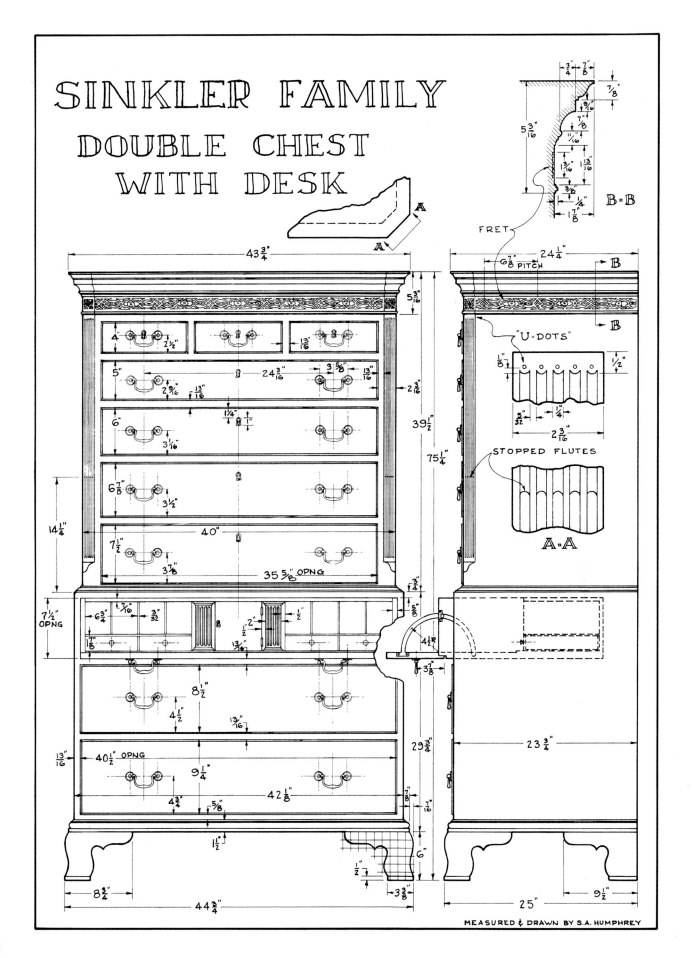

SINKLER FAMILY
DOUBLE CHEST
WITH DESK

B·B

FRET

"U·DOTS"

STOPPED FLUTES

A·A

Col. William A. Washington's Double Chest

George Washington's cousin once owned this chest (Plate XXVII). About twenty years younger than George, Lt. Col. William A. Washington, of Virginia, was the son of Bailey Washington, who was the brother of the president's grandfather. After several early Revolutionary battle successes at Long Island, Trenton and Princeton, William was sent to South Carolina to lead a regiment of dragoons.

In early 1780, Col. Washington defeated Tarleton, the British cavalry leader, near Rantowles and Sandy Hill Plantation, owned by Charles Elliott. When Elliott's daughter, Jane, met the dashing young cavalry officer, she fell in love with him and made him a flag which he carried into battle. He again defeated Tarleton, this time at Cowpens. But in 1781, at Eutaw, he was wounded, captured and held prisoner until the next year. On April 21, 1782, Jane and William were married. The British left Charleston in December, and three years later he bought the house on old Fort Street which, in 1830, was straightened into South Battery.

The Washingtons divided their time between their Charleston home and Sandy Hill Plantation, which Jane had inherited from her father. George Washington visited them at Sandy Hill in 1791. William was promoted to Brigadier General in 1798, died in 1810, and is buried at Sandy Hill.

In 1827, just three years before she passed away, Jane Washington presented to Charleston's Washington Light Brigade the flag she had made for William and which he had carried into battle. It is still there at the Brigade's building on the corner of Meeting and George Streets.

Since Col. Washington did not arrive in South Carolina until about five years after Elfe died, the chest must have been sold first to someone else, perhaps to Charles Elliott, his father-in-law. The records of the Charleston Museum, the present owner of this piece, indicate that the chest once belonged to a "Miss Martha Washington," who may have been a descendant of William and Jane named for the President's wife (George and his wife Martha had no children of their own.).

In Milby Burton's books on Thomas Elfe and Charleston cabinetmakers he thanked the Kindigs (Joe, Jr. and Joe, III) for use of their line sketch of Col. Washington's chest. The Kindigs were antiques dealers from York, Pennsylvania, which suggests that the chest may have passed through their hands. The Museum

COL. WM. WASHINGTON'S
DOUBLE CHEST

2"

44½"

40½"

6⅞"

5¼"

1 3/16"

3¾"

4⅞"

3"

13/16"

13/16"

6" OPNG.

18"

40"

7"

41"

3½"

8⅛"

1"

1⅜"

¾"

76"

3/16"

⅞"

7½"

13/16"

30"

8⅜"

42¾"

10½"

9⅜"

5/16"

1½"

4½"

¾"

13/16"

⅜"

6"

3½"

8"

23¾"

1½ SQUARES

1 11/16"

2"

GROOVE AT EDGE
OF APPLIED FRET

⅜"

1⅜"

2 5/16"

¾"

¾"

3"

28½"

U-DOTS

STOPPED
FLUTES

22¾"

2"

7/16"

3/4"

1¾"

¾"

MEASURED & DRAWN BY S.A. HUMPHREY

acquired the chest from the Carolina Art Association.

This chest is similar to the others, with dust boards which reach only about 2/3 of the way to the rear, drawer muntins, fret identical to the others and veneered drawer fronts. It has original bat wing brasses and escutcheons. The fluted quarter columns of the lower section are capped with "U-dots."

Two Desk/Bookcases

These two nearly identical pieces were attributed to Elfe by Milby Burton on the basis of moldings, construction, cypress secondary woods, proportions, cockbeading, muntins and their identical frets which exactly match all the others.

The desk/bookcase with the pineapple finial (Plate XXVIII) is said to have been originally owned by Dr. John (or Jean) Ernest Poyas, although it may have been first owned by Daniel Bourgett, father of Poyas' wife, Rachel. Bourgett died in 1770, which could account for the purchase not appearing in Elfe's Account Book. Pre-1771 sales would have appeared in earlier, now lost, account books. Bourgett left his daughter and son-in-law the lot at 69 Meeting Street where they built a majestic Charleston single house between 1796 and 1800. This elegant piece of furniture was ideally scaled for either of the fine drawing rooms and probably spent several years in the house. In 1976 it was purchased by the Charleston Museum from Mrs. H.S. Burden and may be seen in the Heyward-Washington House.

From a titled English family of Calverts (not the same as the prominent ones in Maryland history) came John Calvert, probably the original owner of the second desk/bookcase (Plate XXIX). As a young man in Charleston, he jointly owned, along with three others, a merchant schooner named *Four Brothers*. He was a bookkeeper, ran a brewery, and was a Commission Merchant. The first of his four marriages took place in 1755.

In 1775, Calvert served as an assistant to Henry Laurens, the largest merchant in Charleston, in his actions as Chairman of the Council of Safety. He was wounded in the Battle of Beaufort in 1779. Calvert was, for a time in 1779, the Secretary of the South Carolina Navy, resigning to become Commissary General of South Carolina. He moved to Columbia in 1779 after the British expelled him from Charleston for refusing to take the oath of allegiance. There he became one of the first County Judges and, in 1787, became one of the City Commissioners, living until 1803.

Just when Calvert acquired the desk/bookcase is not known, but it descended through his daughter Rebecca, who married into the Douglass family. The mother of the present owner, Mrs. J.M. Shoemaker, Jr. of Greenville, South Carolina, bought the piece from a Douglass family member in about 1928. It was in a derelict condition and has since been beautifully restored.

Two of the original brasses survived and were used as patterns for casting the

DESK - BOOKCASE

HEYWARD-WASHINGTON HOUSE

MIRROR

1" SQ.

BASELINE OF SQ. GRID

$6\frac{7}{8}''$

$39\frac{1}{2}''$

$43\frac{3}{4}''$

$2''$

$1\frac{1}{4}''$

$7''$

$5''$

$15\frac{1}{2}''$

$\frac{3}{8}''$

$2\frac{9}{16}''$

$38\frac{5}{16}''$

$1\frac{3}{16}$

$94\frac{3}{4}''$
$(7'-10\frac{3}{4}'')$

$2\frac{1}{4}''$

$8\frac{7}{8}''$

$3\frac{7}{8}''$

$4\frac{1}{4}''$

$14\frac{3}{4}''$

$36\frac{3}{4}''$

$\frac{3}{4}''$

$12\frac{7}{8}''$

$\frac{3}{4}''$

$\frac{1}{4}''$

$\frac{13}{16}''$

$\frac{3}{4}''$

$6\frac{1}{4}''$

$\frac{1}{8}''$

$2''$

$2''$

$4''$

$\frac{7}{8}''$

$2''$

$\frac{7}{8}''$

$5''$

$3''$

$2\frac{1}{2}''$

$19\frac{3}{8}''$

$6''$

$\frac{7}{8}''$

$3\frac{3}{8}''$

$40''$

$\frac{13}{16}''$

$7''$

$\frac{7}{8}''$

$3\frac{3}{4}''$

$\frac{3}{4}''$

$45''$

$33\frac{1}{2}''$

$\frac{3}{16}''$ STRIP

$8''$

$\frac{9}{16}''$ $\frac{1}{2}''$ $1\frac{1}{2}''$ $\frac{1}{2}''$

$6''$

$42\frac{3}{4}''$

$8''$ $3\frac{1}{2}''$

$22\frac{3}{16}''$

$8\frac{1}{4}''$

© 1989 SAH

MEASURED & DRAWN BY S.A. HUMPHREY

DESK·BOOKCASE
ONCE OWNED BY SECRETARY OF S.C. NAVY

RAISED PANEL

A-A

B-B

A
A
B
B

REPEAT

42"

94½"
(7'-10½")

37"

RAISED PANEL

AS RESTORED
CA 1926

PROBABLE
ORIGINAL BASE & FOOT

42½"

MEASURED & DRAWN BY S.A.HUMPHREY

others. The feet are replacements. The pediment of this piece has a dentil molding rather than the Greek key of the other. Both pieces feature the familiar figure eight and diamond fret. Both frets are identical and measure 1 3⁄16″ wide x 6 7⁄8″ repeat — like all the others. The background frets of the pediments are identical.

Down the front corners of both desk drawer sections are narrow strips of mahogany flush with the front face. Concealed behind these strips are the dadoed slots where the drawer dividers join the sides. No dowels, nails or screws were used. Similar strips were used on the Lynes family desk. The drawer dividers on both pieces extend only about 3⁄4 of the way to the rear wall, like most of the other pieces. Both desks have reinforcing muntins in the large drawer bottoms.

The interiors of both desks are fitted with pigeonholes and drawers grouped around a central door. The Calvert family desk has a replacement interior door. On either side of both doors are fluted column letter files. Both pieces have secret drawers in the interior, and there are drawers across the bottoms of both bookcase sections.

Four-Poster Bed, Heyward-Washington House

This graceful bed (Plate XXXI) is closely related to the other pieces of Charleston furniture. Like the bed in the S.C. Governor's mansion, it has "U-dots" at the upper ends of the footpost's flutes (Plate XXXII). These devices also appear on the fluted corners of Charleston double chests and on the letter drawers of some Charleston slope-front desks.

A very similar bed in the Winterthur collection (Figure 35) was once thought to be of New York origin. Appearing in the book, *Winterthur Guide to American Chippendale Furniture — Middle Atlantic and Southern Colonies*, that bed was described as having:

"...typical New York cabriole legs with leaf-carved knees and square claw-and-ball feet.... The rear posts, usually plain and covered by a side curtain, are here tapered and end in turned balusters supported by pedestal bases."

This bed is now attributed to Charleston by both MESDA and Winterthur. It not only closely matches the Heyward-Washington House bed, but the head posts of both beds are tapered and the lower portions are turned like balusters. All three beds have "eagle claw feet" (Plate XXXIII), as Elfe described several of the beds he sold. They all have stopped flutes. Carved acanthus leaves grace the knees of this bed and the one at Winterthur.

Nothing is known of the early history of this bed. It was purchased by the Charleston Museum in 1949 with funds provided by Mrs. Archer Huntington. The bed had been in the William Ravenel house at 13 East Battery.

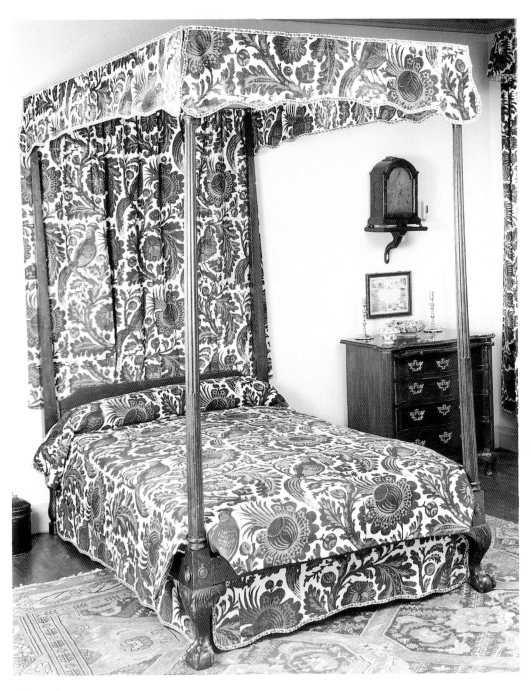

FIGURE 35

FOUR · POSTER BED
HEYWARD · WASHINGTON HOUSE

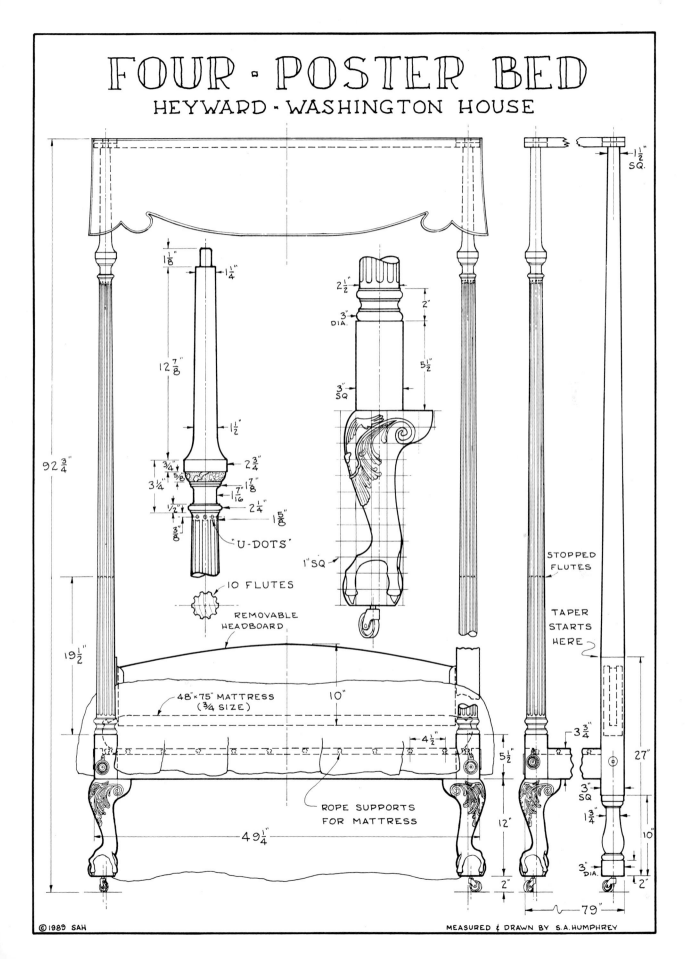

92¾"

12⅞"

1⅛"
1¼"
1½"
¾"
⅝"
3¼"
½"
⅜"

2¾"
1⅞"
1 7/16"
7/8"
2¼"
1⅝"

"U-DOTS"

10 FLUTES

REMOVABLE HEADBOARD

2½"
3" DIA.
2"
5½"
3" SQ.

1" SQ

1½" SQ.

STOPPED FLUTES

TAPER STARTS HERE

19½"

48"×75" MATTRESS (¾ SIZE)

10"

4½"

ROPE SUPPORTS FOR MATTRESS

49¼"

5½"

12"

2"

3¾"

3" SQ

1¾"

27"

10"

3" DIA.

2"

79"

© 1989 SAH

MEASURED & DRAWN BY S.A. HUMPHREY

French Chair

Upholstered, open armed chairs were called "French chairs" by both Chippendale and Elfe. This beautiful example (Plate XXX), with its yellow silk damask upholstery, crisp fret, and rows of shiny brass nails is currently in the Heyward-Washington house of the Charleston Museum.

Milby Burton pointed out that many upholstered chairs found in Charleston were arbitrarily thought to be of English origin or from some other American city if they had brass nails trimming their upholstery. Somehow, Charleston furniture builders were not credited with the use of brass nails. Yet Elfe listed 40,000 brass nails in his inventory, so there must be a great many lost Charleston chairs.

Burton attributed this chair to Elfe based on the fret and the fact that the chair had a long history of ownership in a Charleston family, even though the fret does not match the other examples. It combines both incised and applied frets on its legs. The secondary woods are ash and long-leaf pine, which were used not only in Charleston, but in other places as well.

This chair was purchased for the Charleston Museum in 1960 from Peter Schwerin, an antiques dealer in Charleston. It was repaired in 1961. Mr. Schwerin confirmed that the chair had, indeed, been owned by a local family which had requested anonymity. He added that originally there had been a pair of chairs, so there may still be another one.

Elfe built only a few of these chairs, usually in pairs, during the period covered by his Account Book. He charged £ 60. The price indicates they were richly turned out like this elegant example.

FRENCH CHAIR
HEYWARD·WASHINGTON HOUSE

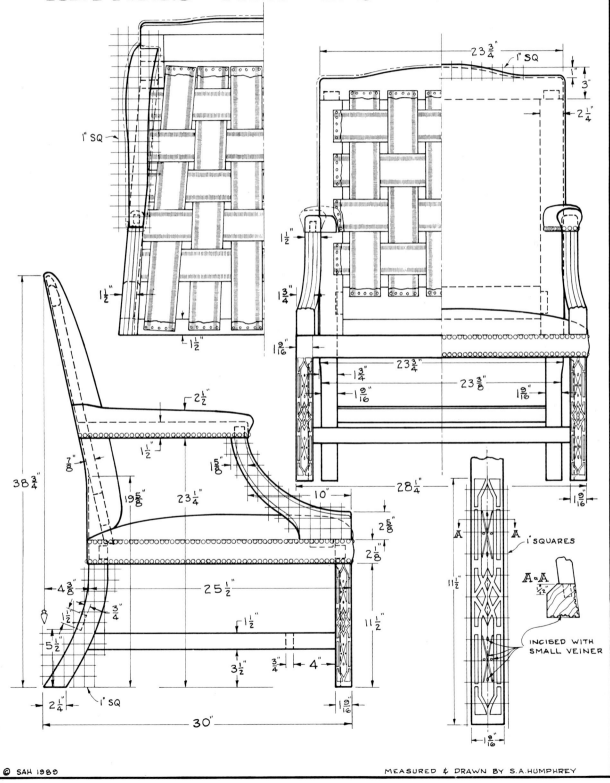

© SAH 1989

MEASURED & DRAWN BY S.A.HUMPHREY

Slope-Front Desk

This desk (Plate XXXIV), now at the Heyward-Washington House, once stood at Foxbank Plantation, the home of Samuel Lynes on the Cooper River, near Monck's Corner. The desk and plantation both descended through his family and were acquired by William H. Wallings, who donated the desk to the Charleston Museum sometime before 1952.

With cypress secondary wood — the Charleston fingerprint — this desk has many of the same characteristics as the other case pieces in the Charleston body of furniture. Most significant are the "U-dots," which appear on the fluted, pilastered letter drawers on either side of the central door in the desk compartment (Plate XXXV).

Very similar to the desk/bookcase of the Poyas family, this desk also appears to have dadoed joints between the drawer dividers and sides of the desk portion. These are concealed beneath 5/16" strips glued to the front edges of the sides. Without fasteners or cross-grain supports, this type of construction has resulted in no splits. The drawer fronts, fall front and small door in the desk compartment are all veneered with figured mahogany.

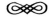

LYNES FAMILY · FOXBANK PLANTATION
SLOPE · FRONT DESK
NOW IN HEYWARD-WASHINGTON HOUSE
CHARLESTON MUSEUM

© SAH 1989

MEASURED & DRAWN BY S.A. HUMPHREY

Triple Chest

This unusual chest design has long been associated with Thomas Elfe's body of work; however, one of its details does not match those of other Charleston pieces. Although the foot pads are much thicker, it was learned that the present feet (shown in the photo and drawing) are replacements, as are the brasses on the front of the chest (Plate XXXVI).

This information came from Peter and Maree Schwerin, who operated the Colonial Antique Shop in Charleston. They are third-generation antique dealers, and remember the days in the 1950s when Milby Burton visited their shop two or three times a week and vied with Frank Horton at MESDA for fine antiques for their respective museum collections.

The history of the chest is not known beyond the fact that it was acquired by Milby Burton for the Charleston Museum in 1956 from Miss Emma H. Mackenzie. It had been part of the furnishings of her rooming house over the Aimar Pharmacy at 409 King Street, an ante-bellum building north of Calhoun Street. With cypress and white pine secondary woods, and the uppermost drawer directly against the top, with no intervening divider strip, this chest would certainly seem to be a Charleston piece.

The large batwing brasses on the ends of each section support the idea that this chest was meant to be moved between townhouse and plantation. A pair of the same brasses may be found on the sides of Mr. Gibbs's chest.

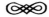

CHEST on CHEST on CHEST
HEYWARD · WASHINGTON HOUSE

DOVETAILS

A·A

DOVETAILS

MEASURED & DRAWN BY S.A. HUMPHREY

Conclusion

While the absence of labels and other forms of documentary evidence have cast doubts about the validity of Thomas Elfe furniture attributions, so far no other Charleston cabinetmaker has yet been shown to be responsible for so much furniture. Modern research methods using computer data bases, such as MESDA's, may permit more advanced study of Charleston furniture and Charleston cabinetmakers.

The Charleston furniture which Elfe may or may not have built or sold may be seen in several museums. The Metropolitan Museum of Art in New York City has at least one piece — the eagle claw foot easy chair with cypress secondary wood. Winterthur Museum near Wilmington, Delaware has the four-poster bed with baluster turned, lower headposts which match those of the Charleston Museum bed in the Heyward-Washington House.

Colonial Williamsburg proudly exhibits the pedimented double chest with fret which belonged to the Deas family of Charleston. MESDA's precisely assembled Charleston rooms are filled with outstanding works of Charleston furniture, including two pieces with "Elfe fret."

The Charleston Museum's collection of eighteenth century furniture is displayed in the Heyward-Washington House on Church Street. Here are some of the finest examples of Charleston Chippendale furniture. Still more is in private collections and may be seen occasionally on house tours. Current photo books of Charleston now feature several antiques with Elfe attributions in the great homes of Charleston.

Appendix A

Thomas Elfe did not create this shelf design (Plate XXXVII), but it is roughly adapted from the cornice of the desk/bookcase in the Heyward-Washington House. It came about when my daughters each requested shelves for their homes and before I noticed the exact match between all of the Charleston Elfe frets. This one is a little different. A similar adaptation would also make a nice fireplace mantel.

The Charleston, or Elfe, fret comes in any size you make it, although width and repeat lengths were identical on all of the antiques measured for this book. The maker generally centered the fret strips on one of the flower-like figures between the figure eights. Thin fret designs may be glued for carving to a softwood backing plank with hide or white glue, using an intermediate piece of paper to later facilitate removing the finished carving with either hot water or steam. This avoids splitting and breaking which might otherwise occur. In any case, keep the white glue handy for repairs, but keep it off surfaces that will later be finished. Wash it off with water if necessary to keep it from showing through.

Elfe and many other English and American cabinetmakers used Greek key in their compositions. Some did not carefully match key terminations at opposite ends or avoid ending a run in the middle of a leg. Fine Charleston work, however, was usually very carefully made, even though most of it must have been done by slaves or apprentices. Careful, accurate layout is the secret. Make the horizontal and vertical legs of the key roughly equal in width and be sure that both outer legs turn up at the ends. Turn the key around the corner. By a small adjustment, the side keys can also be worked out evenly.

THE "ELFE SHELF"
AN ADAPTATION

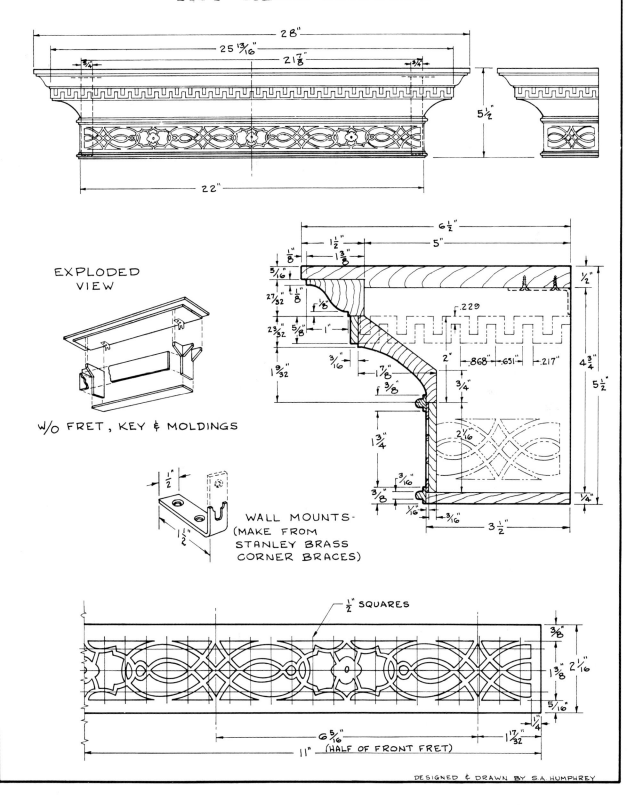

EXPLODED
VIEW

W/O FRET, KEY & MOLDINGS

WALL MOUNTS-
(MAKE FROM
STANLEY BRASS
CORNER BRACES)

½" SQUARES

(HALF OF FRONT FRET)

DESIGNED & DRAWN BY S.A. HUMPHREY

Appendix B

This double chest (Plate XXXVIII) is not so tall as the others, just 69 1⁄4″ while most of the others are 75″ to 76″. Getting a handkerchief from the top drawer is easier, while its size makes it at home in smaller rooms. Although not believed to be an Elfe piece, it has many similar features such as:

1. The fret. Although its dimensions differ from others, the center-front section is similar to part of the lower fret on the MESDA library/bookcase and the elements are half-rounded in cross-section rather than square.

2. The Greek key.

3. The cockbeaded drawer fronts.

4. The muntin braces in the long drawer bottoms, although the grain direction of the actual bottoms is front-to-rear with bottoms nailed to the backs from below.

5. The chamfered and fluted corners with an Elfe-like lamb's tongue and a pleasing upper flare-out which permits using the simpler square-cornered cornice seen in the desk/bookcase in the Heyward-Washington House, rather than the more complex chamfered cornices of the other pieces. There are no stopped flutes and the flute terminations are square, rather than rounded.

6. The drawer stops.

7. The drawer divider/dust stops which reach about 3⁄4 of the way to the rear.

8. The feet, although the base pads are splayed outward slightly. Base and waist moldings are different.

Nothing is known of the history of this piece including either its builder or date of construction; however, it has been through at least one restoration. Not claimed to be an Elfe piece, it is currently part of a private Charleston collection.

ADAPTATION DOUBLE CHEST
ELFE STYLE

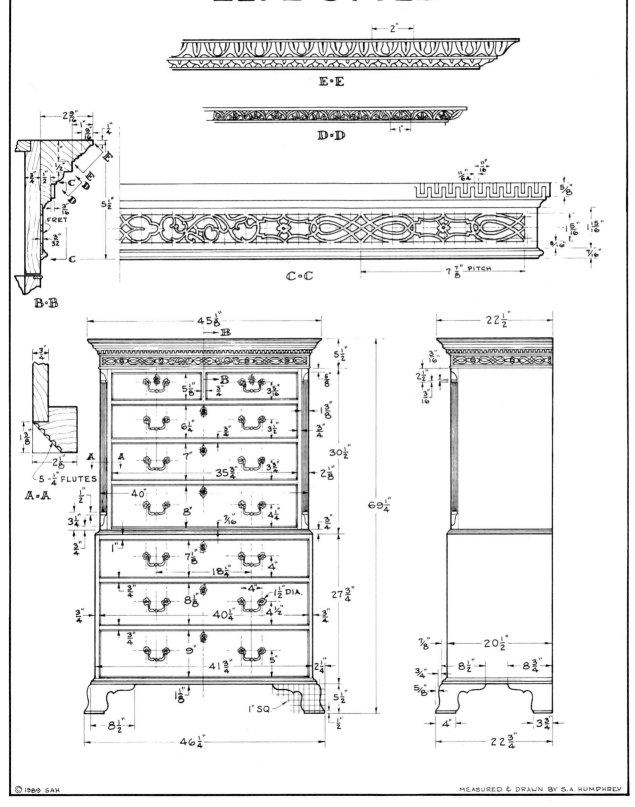

E·E

D·D

C·C

B·B

A·A

FRET

5 - ¼" FLUTES

1" SQ

MEASURED & DRAWN BY S.A. HUMPHREY

References

Bates, Elizabeth B., and Jonathan L. Fairbanks. *American Furniture—1620 to the Present.* New York: Richard Marek Publishers, 1981.

Beckerdite, Luke. "Philadelphia Carving Shops, Part II: Bernard and Jugiez." *Antiques* Sept 1985: 498.

Bivins, John Jr. "Charleston Rococo Interiors, 1765-1775: 'The Sommers Carver.'" *Journal of Early Southern Decorative Arts.* MESDA Nov. 1986: vol XII, no 2.

Brackett, Oliver. *Thomas Elfe, Eighteenth Century Charleston Cabinetmaker.* Boston and New York: Houghton Mifflin Co., 1925.

Burton, E. Milby. "Charleston Furniture." *Antiques Magazine at Charleston.* Apr. 1970.

—. *Charleston Furniture 1700–1825.* Charleston: Charleston Museum, 1955.

—. *The Siege of Charleston.* Columbia, SC: University of South Carolina Press, 1970.

—. *Thomas Elfe—Charleston Cabinetmaker.* Charleston: Charleston Museum, 1952.

Cantor, Jay E. *Winterthur.* New York: Harry N. Abrams Publisher, 1985.

Chamberlain, Richard and Narcissa. *Southern Interiors of Charleston, S.C.* New York: Hastings House, 1956.

Chippendale, Thomas. *The Gentleman and Cabinet-Maker's Director.* Reprint of 3rd ed.: Dover Publications, 1966.

Coleridge, Anthony. *Chippendale Furniture circa 1745–1765.* New York: Clarkson N. Potter, Inc, 1968.

Comstock, Helen. *American Furniture, 17th, 18th, and 19th Century Styles.* Viking Press, 1962.

Downs, Joseph. *American Furniture, Queen Anne and Chippendale Periods.* A Winterthur Book. Macmillan, 1952.

Edmunds, Frances R., "Living with Antiques in Charleston." *Antiques Magazine at Charleston.* Apr. 1970.

Evening Post/News and Courier. *60 Famous Homes of Charleston, SC.* 5th ed., 1978.

Gilbert, Christopher. *The Life and Work of Thomas Chippendale.* New York: Macmillan, 1980.

Gowan, Alan. *Images of American Living.* Philadelphia and New York: J.B. Lippincott Co., 1964.

Greenberg, Allen. "The Diplomatic Reception Rooms of Edward Vason Jones." *Antiques.* July, 1987. 88.

Greene, Jack P. "Colonial South Carolina and the Caribbean Connection." *South Carolina Historical Magazine.* Vol. 88, No. 4. Oct. 1987.

Gusler, Wallace B. "The Tea Tables of Eastern Virginia." *Antiques.* May 1989, 1238.

Heckscher, Morrison H. *American Furniture in the Metropolitan Museum of Art, Late Colonial Period: The Queen Anne and Chippendale Styles.* New York: Random House, 1985.

Hind, Jan, Bradford L. Rauschenberg, and Frank L. Horton. *Journal of The Museum of Early Southern Decorative Arts.* (1979) MESDA.

Hummel, Charles F. *A Winterthur Guide to American Chippendale Furniture, Middle Atlantic and Southern Colonies.* New York: Crown Publishers, 1976.

Iseley, Jane, Agnes Baldwin, and William Baldwin, Jr. *Plantations of the Low Country, S.C., 1697–1865.* Greensboro, N.C.: Legacy Publications, 1985.

Iseley, Jane and Henry Cauthen. *Charleston Interiors.* Preservation Society of Charleston, 1979.

Iseley, Jane and Evangeline Davis. *Charleston Houses and Gardens.* Preservation Society of Charleston, 1975.

Kolbe, John Christian. *Thomas Elfe, Eighteenth Century Charleston Cabinetmaker.* Masters Thesis. University of South Carolina History Department. 1980.

Lytle, Sarah. "Middleton Place." *Antiques Book of American Interiors.* Ed E.D. Garret. 1980.

Lockwood, Luke Vincent. *Colonial Furniture in America.* 3rd ed. New York: Castle Books, 1951.

MacDowell, Dorothy Kelly. "Family History–Sinkler (Sinclair) Family of South Carolina." *South Carolina Magazine.* S.C. Historical Society, Fall 1974.

Michie, Audrey. "Charleston Upholstery In All Its Branches, 1725–1820." *MESDA.* Ibid. Nov 1980, vol XI, no 2.

Moltke-Hansen, David. "The Problem of South Carolina." *South Carolina Historical Magazine.* July 1988. vol 88, no 3.

Rauschenberg, Bradford L. "The Royal Governor's Chair: Evidence of Furnishings South Carolina's First State House." *MESDA.* Ibid. Nov 1980, vol VI, no 2.

Ravenel, Henry E. *Ravenel Records.* Atlanta, GA: The Franklin Printing and Publishing Co., 1898.

Rothery, Agnes. *Houses Virginians Have Loved.* Bonanza Book Ed. New York: Crown Publishers, 1954.

Savage, Tom, and Jane Iseley, Historic Charleston Foundation. *Nathaniel Russell House.* Greensboro, N.C.: Legacy Publications, 1986.

Simons and Lapham. *The Early Architecture of Charleston.* 2nd ed. Columbia, S.C.: University of South Carolina Press, 1970.

Smith, Alice R. Huger and D. E. Huger. *The Dwelling Houses of Charleston.* New York: Diadem Books, Barre Publishing Co., 1917.

Theus, Mrs. Charlton M. *Savannah Furniture 1735–1825.* Privately Published. 1967.

Thomas, W.H. Johnson. "Seven Great Charleston Houses." *Antiques Magazine at Charleston.* Apr. 1970.

Trinkley, Michael. *A Historical and Archeological Evaluation of the Elfe and Sanders Plantations, Berkeley and Charleston Counties, South Carolina.* Columbia, S.C.: Chicora Foundation, Inc., May 1985.

Webber, Mabel L. "The Thomas Elfe Account Book, 1768–1775." *South Carolina Historical Society Historical and Geneological Magazine.* Jan 1934, XXXV–XL

Williams, George W. *St. Michael's, Charleston, 1751–1951.* Columbia, SC: University of South Carolina Press, 1951.

Winchester, Alice, Marshall B. Davidson, E. Milby Burton, and Helen Comstock. *Southern Furniture 1640-1820. Antiques* Magazine Book. 1952.

—. "Museum Accessions." *Antiques.* Jan. 1985. 132.

Other Sources

Charleston County, S.C. "Land Records." Misc, Pt. 34, Book E3, 1765-1766. 621-626
 9 June 1763: Sale by Thomas Elfe to Richard Hart of part of lot #250 on north
 side of Queen Street.
Charleston County, S.C. "Wills, etc." *The Inventory of the Estate of Thomas
 Elfe–11 Sep 1776.* Vol 99A, 1776-78. (transcript) 116.
Charleston County, S.C. "Wills, etc." *Thomas Elfe Will–7 July 1775.*
 No.18, 1776-1784., 88.
Curator's Worksheet. Colonial Williamsburg, 1975. *Charleston Chest on Chest.*
 (acc. # 1974-166)
Curator's Worksheet. Colonial Williamsburg, 1985. *Virginia Royal Governor's
 Chair..* (acc. # 1930-215)
Elfe Descendants, Mrs. Virginia Elfe Zeigler, John Zeigler, Virginia Potter.
 Interview. 27 Oct. 1988.
Historic American Buildings Survey, "HABS No. SC-286," 54 Queen Street,
 Historic Information, S. G. Stoney 1963: Stoney identified No. 54 Queen as
 part of lot #83 belonging either to Alexander Peroneau or his son-in-law
 John Edwards.
Historic Charleston Foundation. *Reproduction & Accessories* catalog. Atlanta:
 Williams Printing Co., 1986.
Smith, Edwin H. Unpublished papers of Edwin H. Smith, Charleston
 Cabinetmaker, 1916-1979. South Carolina Historical Society.

Photo Credits

Black & White: Page 11, The Metropolitan Musuem of Art, Kennedy Fund, 1918. (18.110.25); Pages 16, 17, 46 (b), 46 (c), 52, 54, 56, Museum of Early Southern Decorative Arts; Page 27, Terry Richardson; Page 45, McKissick Museum; Pages 46 (a), 67, Colonial Williamsburg Foundation; Page 60, Smithsonian Institution Photo No. 88-5266; Page 73, Governor's Mansion; Page 100, Courtesy, Winterthur Museum.

Color: Plates I, II, IV, VI–XIII, XXI, XXIII–XXVIII, XXX–XXXVII, T. R. Richardson; Plates III, V, XVI, XXXVIII, Samuel A. Humphrey; Plates XVII, XX, XXII, Museum of Early Southern Decorative Arts; Plates XVIII, XIX, Shirley Plantation; Plate XXIX, Wes Walker.